# GARBAGE PAIL KIDS

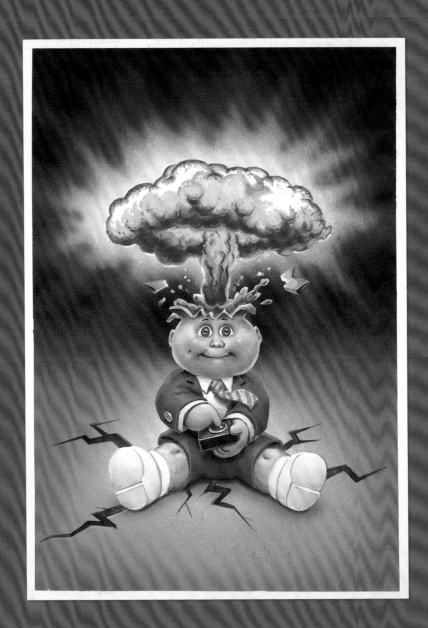

# GARBAGE PAIL KIDS ™

By The Topps Company, Inc.

Introduction by Art Spiegelman
Afterword by John Pound

Abrams ComicArts, New York

ACKNOWLEDGMENTS: Thanks to Ira Friedman and Colin Walton at Topps (without whom . . .); Art Spiegelman and John Pound for their editorial contributions, as well as for their generosity and all-around availability to help this book come together; Geoff Spear (photography); Jacob Covey (Photoshop work on the cover); and at Abrams ComicArts: Charles Kochman (editorial), Kari Pearson (editorial assistance), Neil Egan (design), Chad Beckerman and Liam Flanagan (design assistance), Scott Auerbach (managing editorial), and Alison Gervais (production). Finally, a very special thanks to Art Spiegelman, Mark Newgarden, Len Brown, John Pound, Tom Bunk, David Burke, and Mae Jeon for the creation of this material, and to Jay Lynch, James Warhola, Arthur Shorin, and Stan Hart for their help.

Every effort was made to keep the quality of images consistent throughout this book. Most were reproduced from transparencies of the original art. A handful of images are from digital files (stickers 37, 39, 101, 125, 149, 158, 164, 176, and 197) and were "remastered." All type elements were re-created in 2011 to carefully match the originals. Die-lines, however, were not reproduced so that the art could be shown unobscured for the first time. Mistakes have been corrected (for example sticker 9, which was reversed when it was initially printed in 1985).

Two versions of each Garbage Pail Kids sticker were produced by Topps. The same artwork was used; however, different character names were designated with either an "a" or "b" after the sticker number. In a handful of instances a third name shared one of the letters. The "a" stickers are the ones reproduced in this book, with the alternate "b" names listed underneath.

The following is a complete list of artists/credits for Series 1 through 5 (numbers refer to those on the top right of the stickers):

David Burke: 139, 142–47, 153, 159. Tom Bunk: 89–91, 94–95, 103, 111–12, 115–16, 122, 124, 141, 148, 150–52, 154–56, 158, 167, 174–75, 178, 180–81, 183–85, 187, 189, 206. Mae Jeon: 117–18. John Pound: 1–88, 92, 93, 96–102, 104–10, 113–14, 119–21, 123, 125–38, 140, 149, 157, 160–66, 168–73, 176–77, 179, 182, 186, 188, 190–205.

www.garbagepailkids.com

Editor: Charles Kochman
Designer: Neil Egan
Production Manager: Alison Gervais

Cover art: Tom Bunk
Cover design: Neil Egan
Additional Photoshop work on cover: Jacob Covey
Illustrations on sticker backs: Tom Bunk
Additional photography: Geoff Spear

Cataloging-in-Publication has been applied for and may be obtained from the Library of Congress.

ISBN 978-1-4197-0270-9

Printed and bound in China
20 19

Abrams ComicArts books are available at special discounts when purchased in quantity for premiums and promotions as well as fundraising or educational use. Special editions can also be created to specification. For details, contact specialsales@abramsbooks.com or the address below.

ABRAMS The Art of Books
195 Broadway, New York, NY 10007
abramsbooks.com

# PUTTING OUT THE GARBAGE

## by ART SPIEGELMAN

I look back on the early history of comic books—a major vice of mine—and get frustrated by the inability of many of the creators to remember exactly what happened. And yet if I look back on my entire twenty-year-long Topps bubblegum life, it's one big blur. I'd put in my time, and I'd go home. I didn't think of the work I did there in the same way I thought about my comics work: "I am ze *artiste*. I shall put on ze beret." Topps was as close as I ever came to being in the "Real World," working within a corporation that had its own needs, and I would just enter the machine and function inside it as best I could. If somebody quizzed me twenty-four hours later—let alone decades later—about what I'd done there, my memory would be really hazy. It was all just one more day in the ephemera factory.

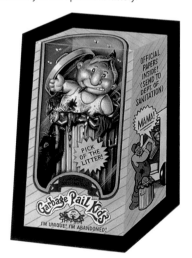

Unpublished Wacky Packages sticker from 1985, painted by John Pound, based on a sketch by Mark Newgarden

What I do remember is that the gig required having good antennae to anticipate whatever phenomenon was likely to become a fad before it peaked, and turn it into a cheap commodity. Sometimes things didn't work out; you guessed wrong. But you did your damnedest. This business has always been, and still is, a crapshoot. So when Cabbage Patch Kids became a phenomenon in the mid-eighties, Topps was very interested in putting out Cabbage Patch Kids stickers, in much the same way they had done with Star Wars and Batman and other licenses over the years.

Thanks to Len Brown, Topps's sweet and savvy creative director, who had the taste of a twelve year old (I say that admiringly), Topps came in *before* Star Wars became a phenomenon, caught the wave, and made a mint. With Cabbage Patch Kids, Topps knocked on the door (along with a lot of other potential licensees), but the knock didn't come early enough to get a cheap license—and cheap is the bottom line when we're talking bubblegum. Topps had come too late in the game to get in on this and make it work financially.

I recall sitting in a meeting one day with Len; Arthur Shorin, the CEO; and Stan Hart, who worked in new product development and had helped to come up with some important Topps products over the years. We were trying to figure out whether it was worth pursuing a Cabbage Patch Kids license, when Stan said, "Well, let's just do a parody." Now, Stan was always a bit of a wildcard in that period, because he seemed to just drop in from outer space for meetings and then go back into outer space, leaving us holding whatever bag he had left on the table, even if it sometimes

smelled a bit peculiar. I'm sure Len and I looked at each other, our lives flashing before our eyes, and one of us asked, "But how do you do more than one sticker?" "I don't know," Stan said, "but we'll figure it out." And by "we" he meant me and Len. Still, it was a very important intervention, because Stan was right, ultimately. We were ready to move on, but he catalyzed something that the rest of us had missed. And now it was just a matter of problem solving—reading the gnomic chicken bones and finding out what they could be turned into. Our job was to figure out how we could make a whole series of parodies out of one object.

At that moment I don't think I even remembered that we had already done a Cabbage Patch Kids parody called "Garbage Pail Kids" as part of an upcoming Wacky Packages series, although Mark Newgarden, who had been responsible for writing and drawing a rough for it, must have dusted off John Pound's rendering and brought it out. But coming up with one gag was easy: you started with "cabbage," and from there you eventually hit on "garbage"—a basic phrase in our vocabulary going back to Garbage Can-dy, one of the first ideas I brought to Topps when I was eighteen and started working there. Garbage Pail Kids was the inevitable name for a Wacky Pack parody, far better than "Cribbage Patch Kids" or "Cabbage Punk Kids" or various other lame names that might come up using the Wacky Pack name generator. It's just that turning one joke into a series seemed impossible.

We tried to visualize them: they're different kids, and they all have different names. Now, the whole idea of the Cabbage Patch dolls is that each one looks slightly different and comes with its own birth certificate. So I can't say this was an act of genius, but because I had been immersed in Topps non–sport card history since my misspent childhood, Ugly Stickers, a series that had been a phenomenon in the mid-sixties,

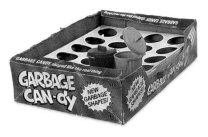

Garbage Can-dy box, first introduced in 1977

soon came to mind. These were really grotesque creatures drawn by two of my comic-book heroes, Wally Wood and Basil Wolverton. The funny-looking creatures were monstrous and memorable. And—almost as an afterthought— names were added to the stickers; nothing fancy, just "Arthur" or "Harvey." But the naming gave them a context, and that was the key to the kingdom. That was what made them an absolute phenomenon—the personalization of these impossibly grotesque creatures was a way of directly engaging the kids.

A later and lesser variation on the same theme was Slob Stickers, illustrated by Jack Davis. Here the names were accompanied by adjectives, as in "Misfit Michael" and "Smelly Steve." Alliteration was an important part of the Topps approach to language.

And shortly after I started at Topps, we did something called Nutty Initials. These were drawn by Basil Wolverton and painted by Norm Saunders. They were fantastic. Kids were able to spell out their names using odd creatures bent into the different letter shapes. A lot of what I did back in those first few years at Topps involved personalization. Some projects were pretty tedious. After Nutty Initials we did Monster Initials, psychedelic Love Initials, and other variants. None of them had the cheerful unwholesomeness that made Wolverton's work immortal. To my mind, these artists were about as close as one could get to working with Rembrandt or Picasso. This was as high as the arts got.

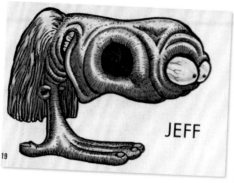

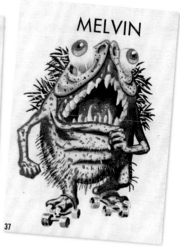

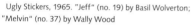

Ugly Stickers, 1965. "Jeff" (no. 19) by Basil Wolverton; "Melvin" (no. 37) by Wally Wood

All that Topps history was the amniotic fluid that the Garbage Pail Kids floated in to get born. But we still didn't know what to make these damn kids look like. We tossed the assignment out to a handful of artists we'd reeled in and asked them to give it a shot, including, as I recall, Robert Grossman. But none of them seemed right, nothing was panning out . . . until we contacted John Pound, who had started working with us on Wacky Packages by that time.

We still needed (a) a prototype gag and (b) a look. We weren't striving for the saccharine cuddliness of the Cabbage Patch dolls—we were aiming at something closer to the Ugly Stickers. Something grotesque, and yet there somehow had to be an endearing aspect to the images as well. Even John's first stabs at it didn't have the right balance of cute and creepy. We had to steer him toward staying more "on model" with regard to the source material while still making it a clear parody. After a little back-and-forth, he hit the bull's-eye. He made you want to adopt those poor rejected kids despite the fact that seeing them might make you want to puke. And from there we had to hone in on a few prototype gags. We knew from experience that if we could find two, we could find two hundred. But if we could only come up with one, we were in trouble.

I sketched out one: a kid literally going nuclear, with a mushroom cloud coming out of his head. It eventually became Adam Bomb (no. 8a). We also tried reworking something that I believe Robert Grossman may have come up with, or maybe it was Mark Newgarden's gag. Or mine; I can't recall. Anyway, it started as a sketch of a little girl with a faucet for a nose and snot running out of it. Snot was a good idea (gross bodily fluids were a staple of Topps's sophisticated brand of humor), but the hook-nosed girl just couldn't pass for a cloyingly cute Cabbage Patch doll–like creature. She eventually evolved into Leaky Lindsay (no. 45a), the little tyke turning her snot into a cat's cradle as it flows out of her sweet little button nose. Looking back, I see that Leaky Lindsay didn't appear until our second series, so . . . maybe it was no. 29a, the skeletal Bony Joanie (skeletons and horror imagery were also part of the Topps DNA), or maybe the kid climbing out of the toilet bowl (potty humor, short of depicting actual turds, was a natural) that became the second prototype. One way or another, we stumbled to the starting line and were on to something that we could turn into a series.

We knew we were going to use names and adjectives to personalize them. We could use the backs as personalizable documents that could add to the humor and cement the parody. (Topps's earlier Nutty Awards and Wanted Posters offered a precedent for this.) Once we knew where we were headed, we had to churn them out quickly—we just didn't know how long the phenomenon was going to last. The first twenty were more or less easy (God knows how we ever came up with the six hundred or so variations we did before it was all over). At that time we didn't know there was going to be more than one series, of course. Things that didn't look so hot the first time around were great by Series 3.

Mark Newgarden, a student of mine at the School of Visual Arts whom I brought to Topps, became an essential part of the Garbage Pail Kids team. My sense of humor tends to be more masochistic than Mark's, which is often sadistic. Mark's gags tended to push the envelope further toward the malevolent—as violent or nasty an image as one could get away with. But between the two of us, we struck a balance that depicted bullying and being bullied—both are important parts of schoolyard life—and from our different vantage points, the series found its point of view.

Throughout, Len was the friendly voice of reason, saying, "No, you can't show a tampon!"

After a while we started to get punchy. We'd go into a trance trying to figure out, say, what we could do with some poor kid's ears that would be graphically compelling. Or how the kid would react to being stabbed. We'd have these sessions where we would all sit around this tiny imitation-wood table in a small room with junk all around it, coming up with jokes about somebody crawling out of a toilet looking like he just ate something.

The naming usually happened after the paintings were done. We'd christen them using lists of popular names and lists of what names we'd already used. I believe Mark and I were primarily responsible for the first few series. John probably chipped in; I don't recall who was doing what exactly, and I don't consciously mean to take anything away from anybody else's contribution. As we went along, we needed to pull in more and more artists just to be able to get these things done. We hired Tomas Bunk to do the spot art on the backs of the first series cards. I'd become friends with him after I'd seen his very Crumb-inspired underground comix from Germany. His work had a lot going on—a very wild energy—and

Nutty Initials by Basil Wolverton and Norm Saunders, 1967

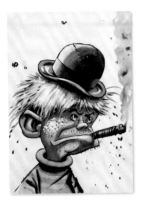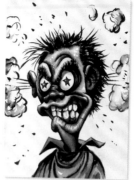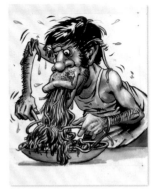

Slob Stickers by Jack Davis, 1966. "Angry Alan"/"Angry Albert" (no. 33);
"Hot-Head Howie"/"Hot-Head Frank"/"Hot-Head Henry" (no. 19);
"Disgusting Donald"/"Disgusting Dom"/"Disgusting Donnie" (no. 3)

he was a great addition to the team who went on to paint fronts in later series and eventually became an official member of *MAD*'s Usual Gang of Idiots. Somehow Andy Warhol's nephew, James Warhola, was steered to us. He could paint, so we were like, "OK, you're on, kid." There were all these people who were very talented, and they could help keep the factory humming. We all worked anonymously, since Topps didn't want the work publicly credited, presumably so we could easily be replaced by other hands. I was annoyed at the time, but my book publisher, Pantheon, was very relieved. The first volume of *Maus* was being prepared for publication while the GPKs were near the height of their popularity. In 1986 it was challenging enough to get people to accept the idea of a serious work about the Holocaust in comic-book form without having to reveal that the artist also created those notorious stickers for the prepubescent set. "Please keep it quiet," my editor insisted. "If this gets out, they'll review your book and call it 'Garbage Pail Jews!'"

Eventually, Garbage Pail Kids became as big a phenomenon as Cabbage Patch Kids. Garbage Pail Kids offered something that was not so benign and parent-friendly; rather, it provoked:

"Oh, my god, what *is* that? Where did you get those? Your allowance is cut off! *And* you're grounded!" The dolls were pricey and had to appeal to adults. The stickers were available for chump change and appealed to the inner beast in all kids.

As a phenomenon—and it really was a global phenomenon—Garbage Pail Kids were one more way to feed back the transgressive lessons I gleaned from Harvey Kurtzman's *MAD*, which also informed even my most serious comics work. We were trying to help another generation of juvenile delinquents come of age, to offer them a counterculture. But not one that was counter to our American Way of Life— we're talking about the bubblegum counter. This was Topps, after all.

**ART SPIEGELMAN** is the Pulitzer Prize–winning creator of the graphic novel memoir *Maus* (1991). He worked for the Topps Company from 1966 (as a summer intern when he was eighteen) until 1989. In addition to his work on Garbage Pail Kids, Spiegelman was part of the creative team that produced Wacky Packages, as well as other humor and entertainment cards and stickers.

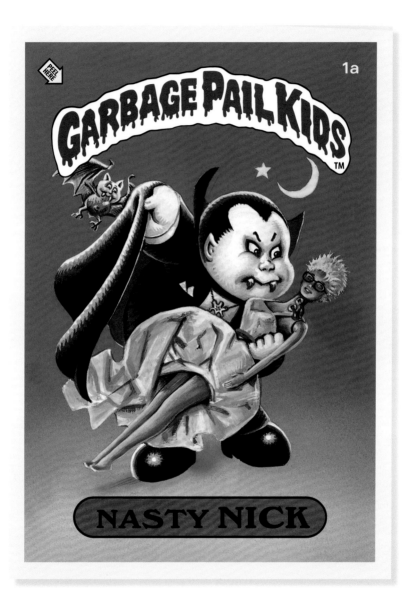

EVIL **EDDIE** 1b

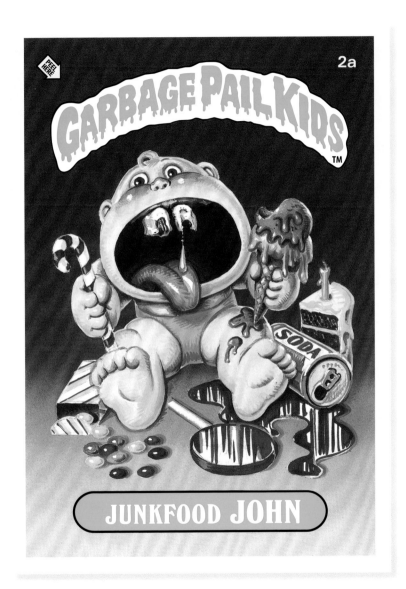

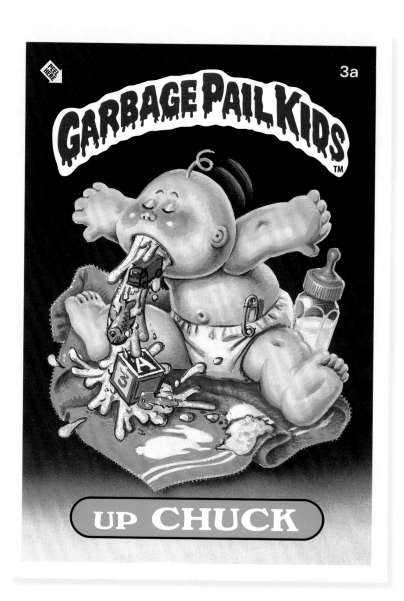

## GARBAGE PAIL KIDS™

## UP CHUCK

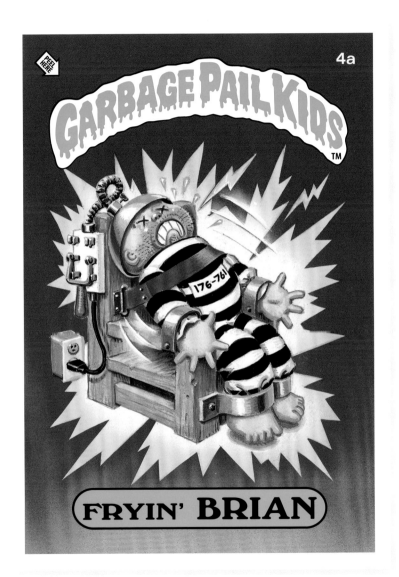

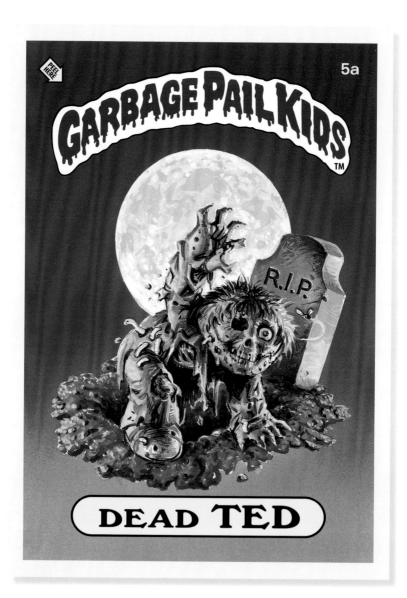

5a

GARBAGE PAIL KIDS™

R.I.P.

DEAD TED

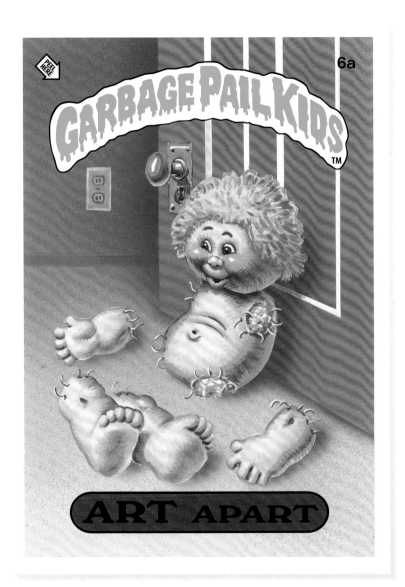

GARBAGE PAIL KIDS™

6a

ART APART

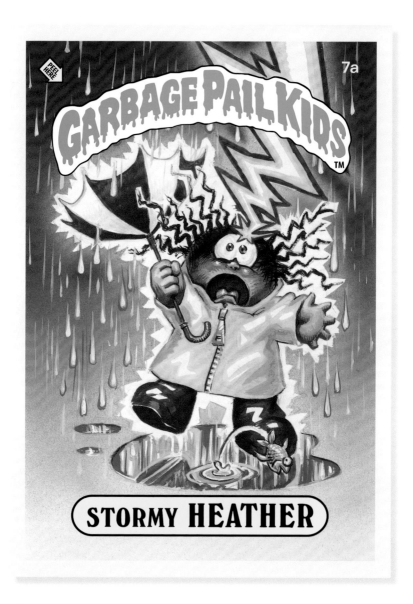

STORMY **HEATHER**

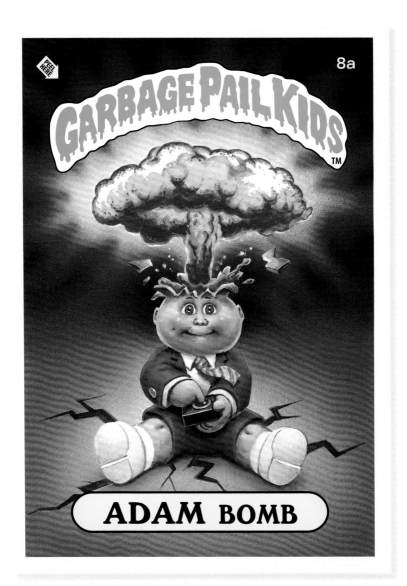

GARBAGE PAIL KIDS ™

ADAM BOMB

BLASTED BILLY 8b

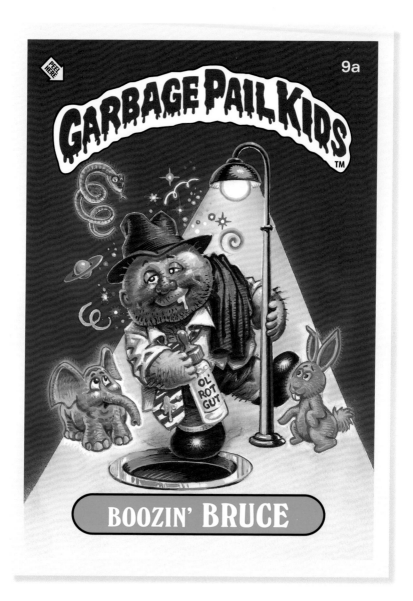

GARBAGE PAIL KIDS™

9a

BOOZIN' BRUCE

DRUNK KEN 9b

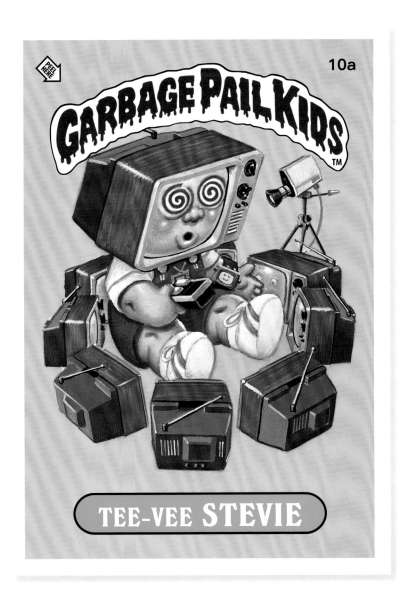

**GARBAGE PAIL KIDS**™

10a

TEE-VEE STEVIE

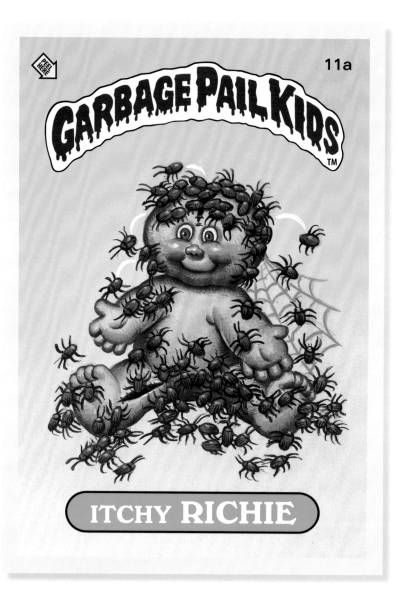

GARBAGE PAIL KIDS™

ITCHY **RICHIE**

BUGGED **BERT** 11b

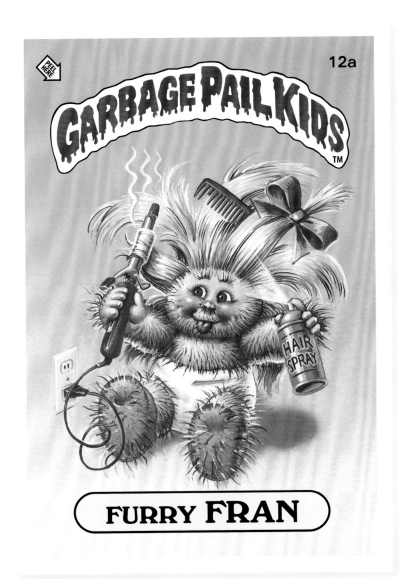

**FURRY FRAN**

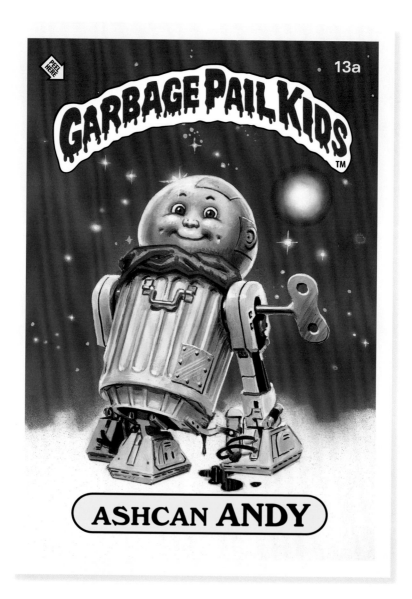

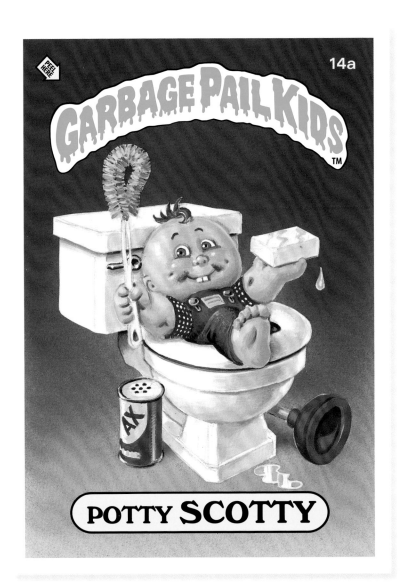

POTTY **SCOTTY**

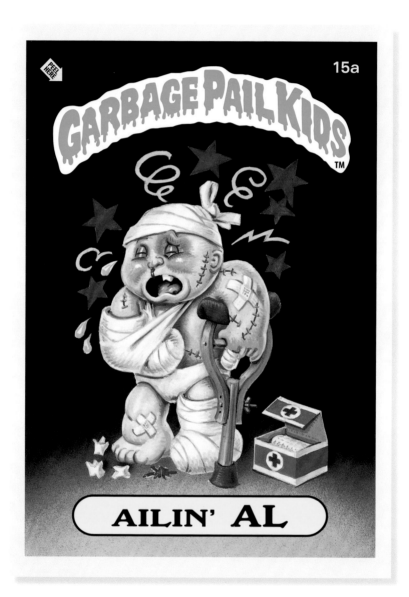

15a

GARBAGE PAIL KIDS™

AILIN' AL

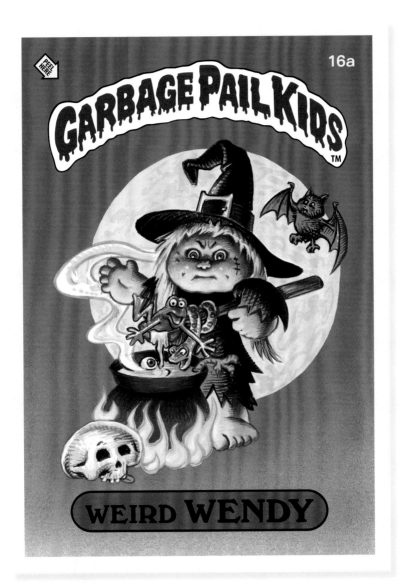

GARBAGE PAIL KIDS™

16a

WEIRD WENDY

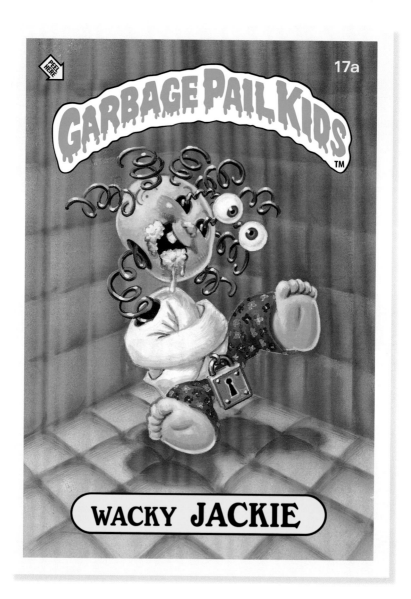

17a

# GARBAGE PAIL KIDS™

## WACKY JACKIE

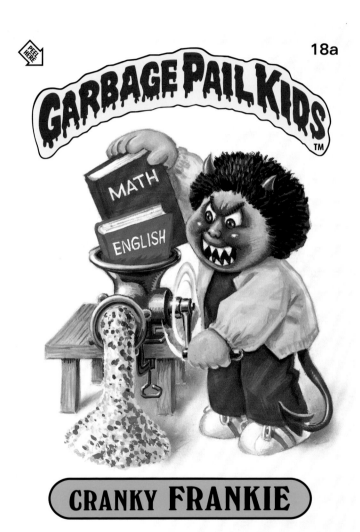

GARBAGE PAIL KIDS™

CRANKY FRANKIE

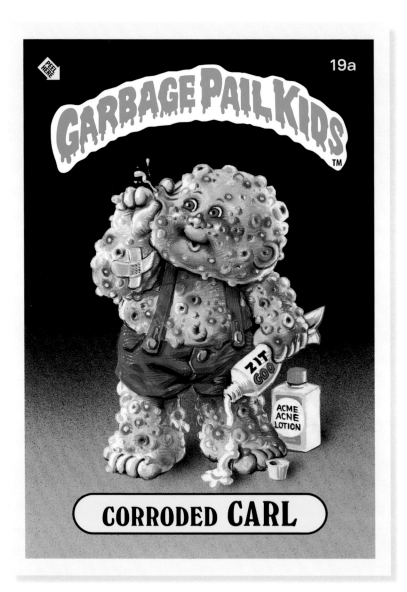

19a

GARBAGE PAIL KIDS ™

ZIT GOO

ACME ACNE LOTION

CORRODED CARL

CRATER CHRIS 19b

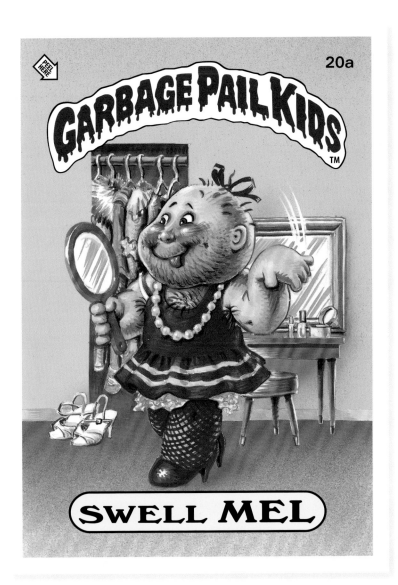

SWELL MEL

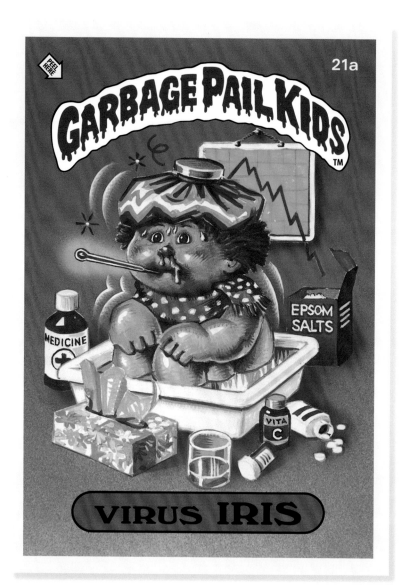

**GARBAGE PAIL KIDS** ™

21a

EPSOM SALTS

MEDICINE

VITA C

**VIRUS IRIS**

SICKY VICKY 21b

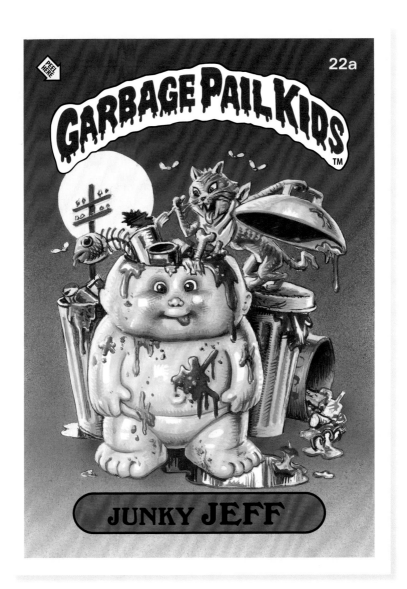

GARBAGE PAIL KIDS™

22a

JUNKY JEFF

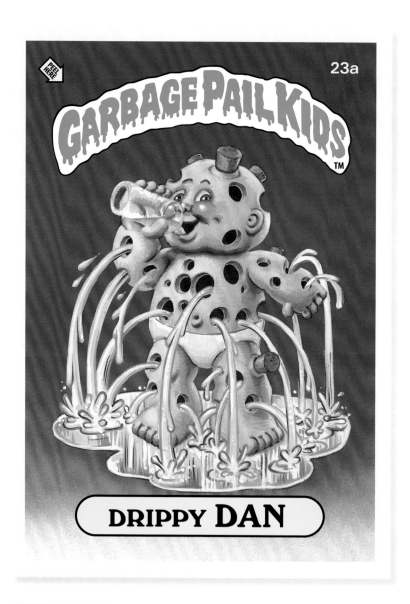

LEAKY LOU 23b

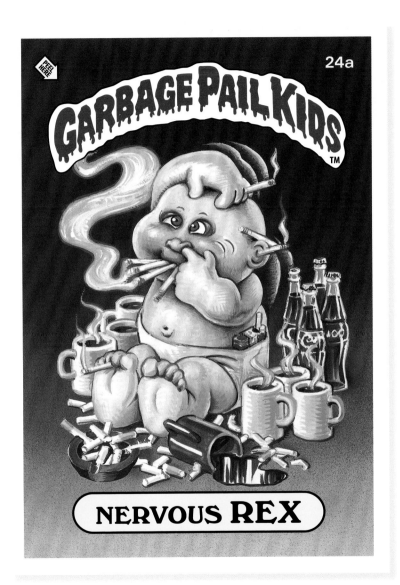

GARBAGE PAIL KIDS™

24a

NERVOUS **REX**

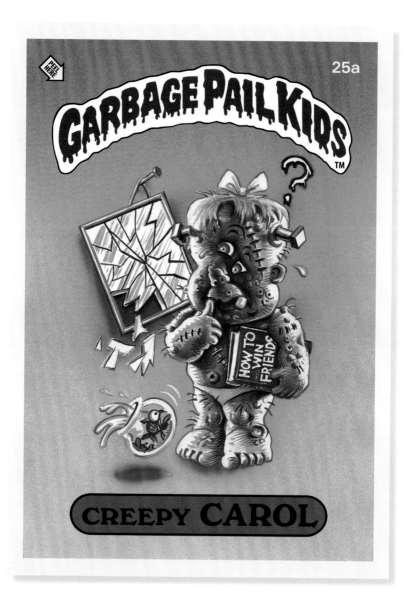

**GARBAGE PAIL KIDS™**

25a

**CREEPY CAROL**

SCARY CARRIE 25b

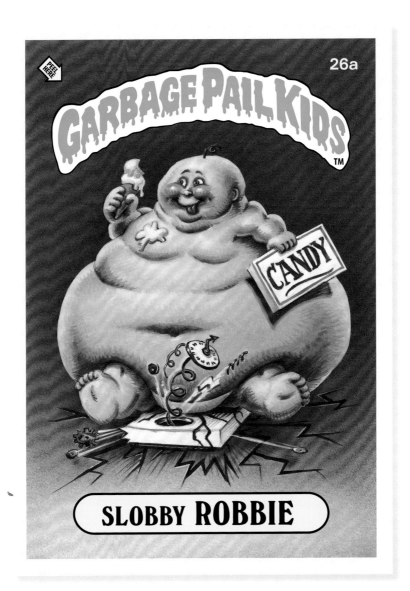

SLOBBY ROBBIE

FAT MATT 26b

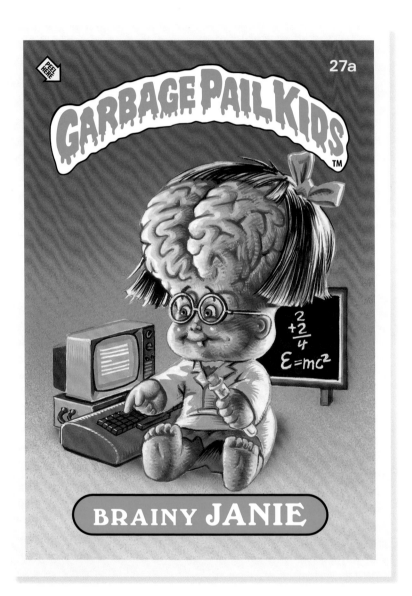

GARBAGE PAIL KIDS™

$$+\frac{\frac{2}{2}}{4}$$

$$\varepsilon = mc^2$$

BRAINY JANIE

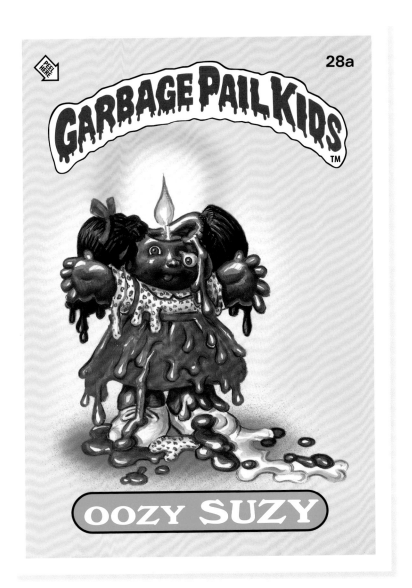

GARBAGE PAIL KIDS™

OOZY SUZY

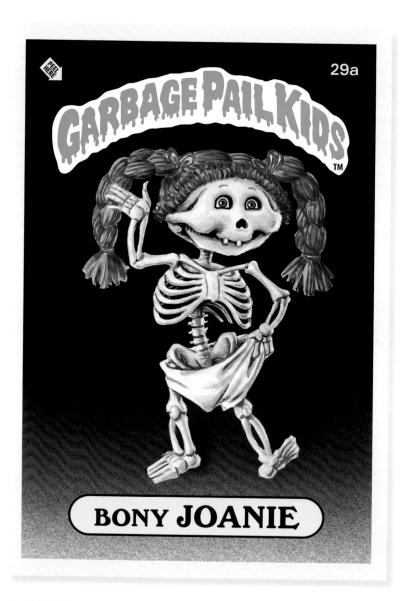

29a

GARBAGE PAIL KIDS™

BONY JOANIE

THIN LYNN 29b

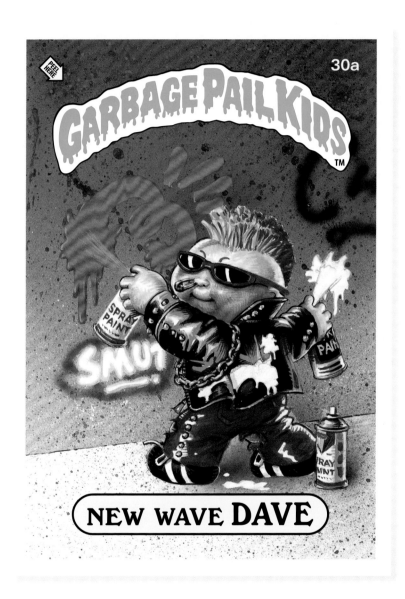

30a

GARBAGE PAIL KIDS™

NEW WAVE DAVE

GRAFFITI **PETEY** 30b

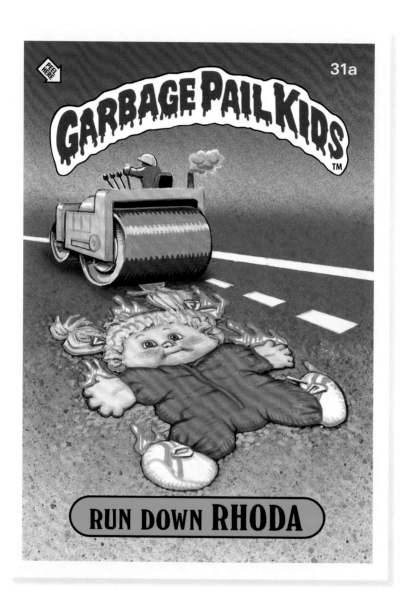

31a

GARBAGE PAIL KIDS ™

RUN DOWN **RHODA**

FLAT **PAT** 31b

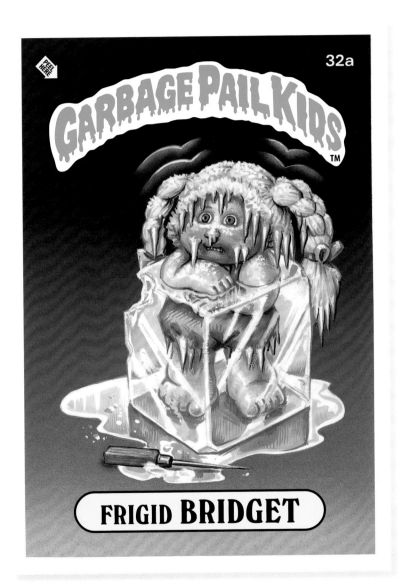

32a

GARBAGE PAIL KIDS ™

FRIGID **BRIDGET**

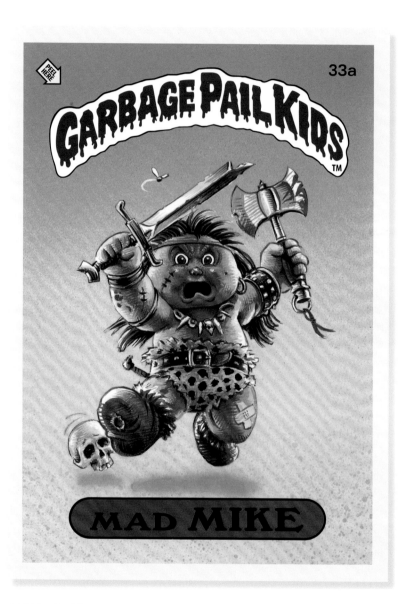

33a

GARBAGE PAIL KIDS™

MAD MIKE

33b

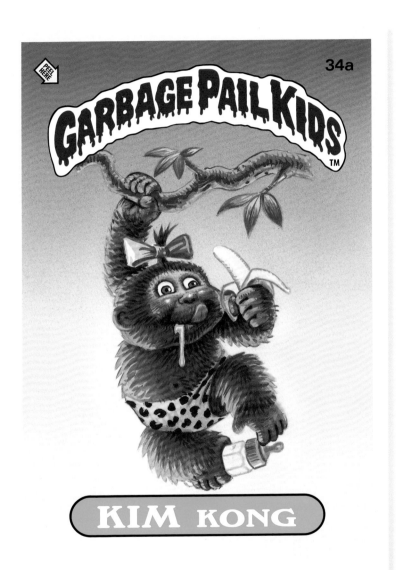

GARBAGE PAIL KIDS

KIM KONG

ANNA BANANA **34b**

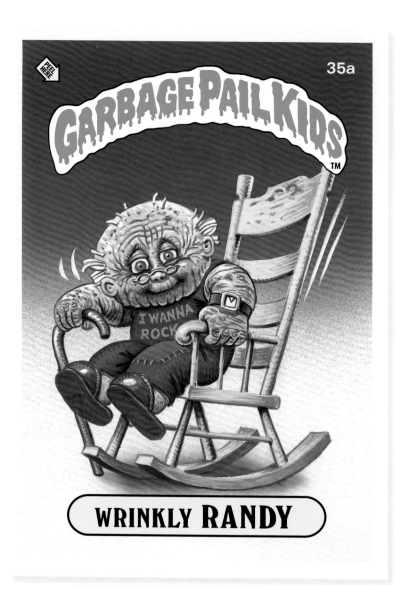

GARBAGE PAIL KIDS™

35a

**WRINKLY RANDY**

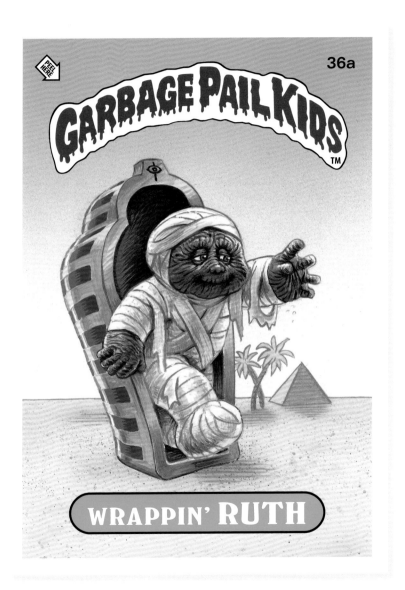

GARBAGE PAIL KIDS

36a

WRAPPIN' **RUTH**

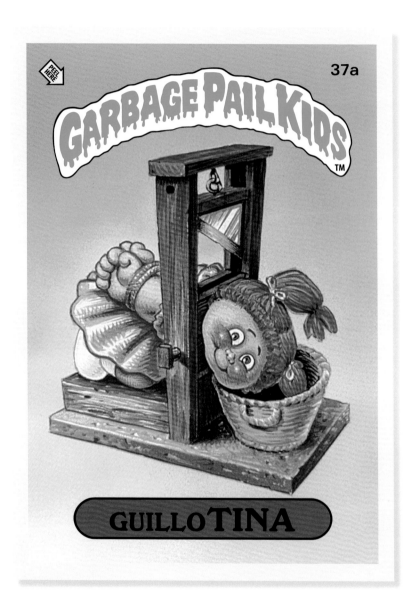

GARBAGE PAIL KIDS™

37a

GUILLOTINA

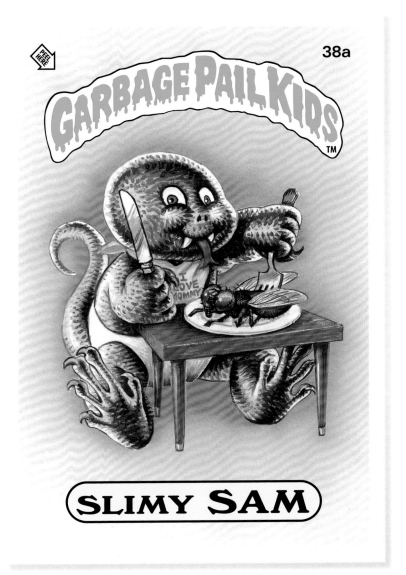

**GARBAGE PAIL KIDS** ™

**SLIMY SAM**

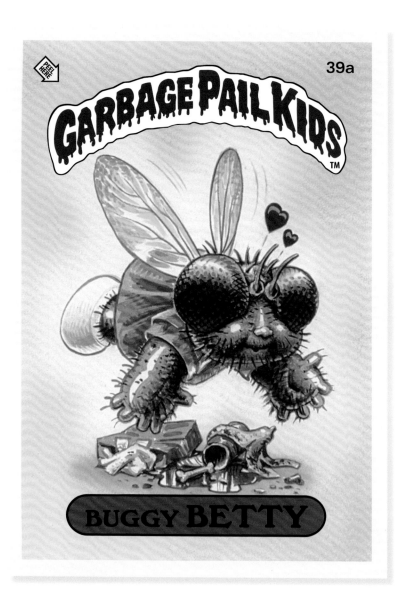

39a

GARBAGE PAIL KIDS™

BUGGY BETTY

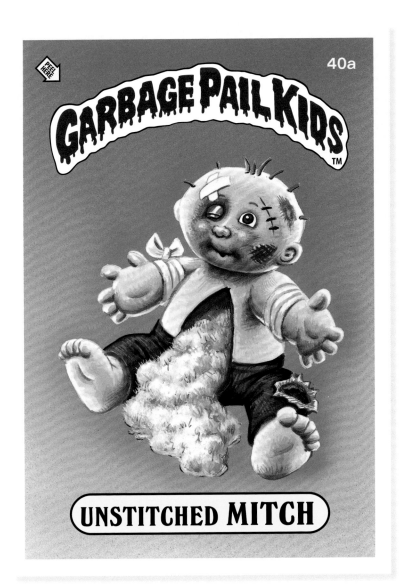

UNSTITCHED MITCH

DAMAGED DON 40b

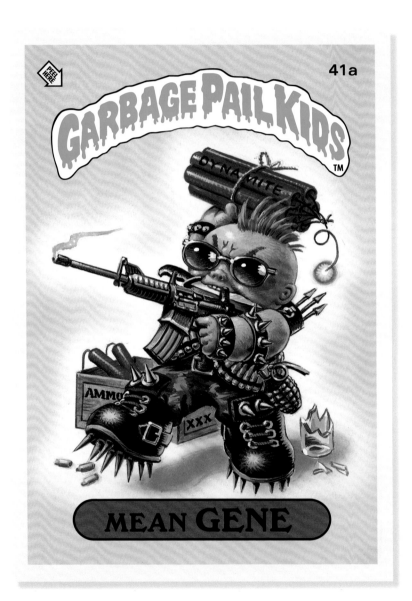

GARBAGE PAIL KIDS ™

PEEL HERE

MEAN GENE

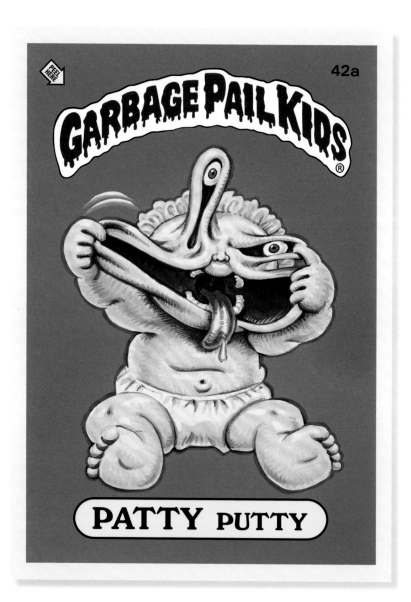

42a

# GARBAGE PAIL KIDS

**PATTY** PUTTY

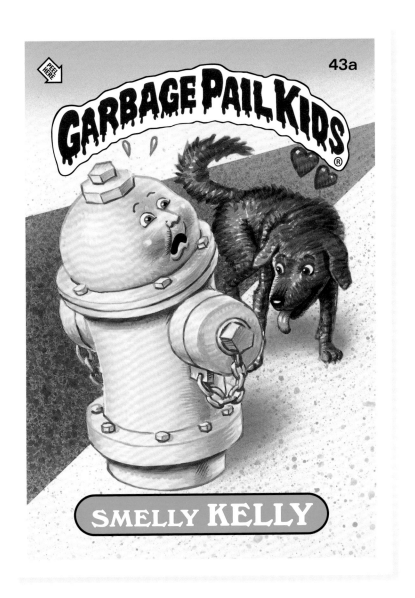

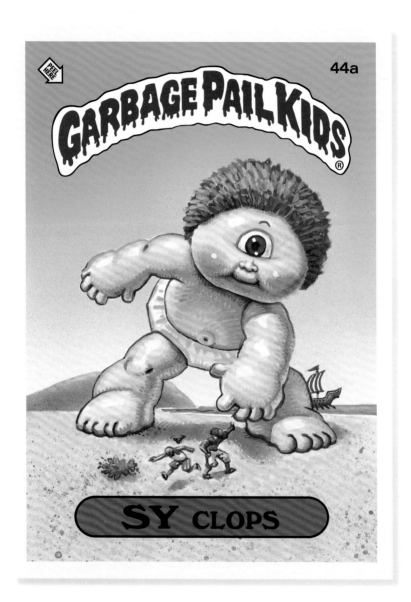

44a

GARBAGE PAIL KIDS

SY CLOPS

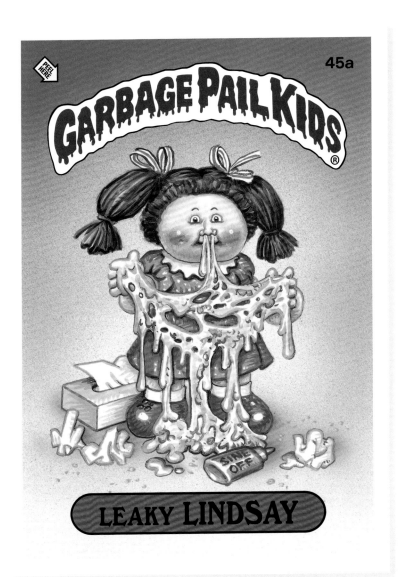

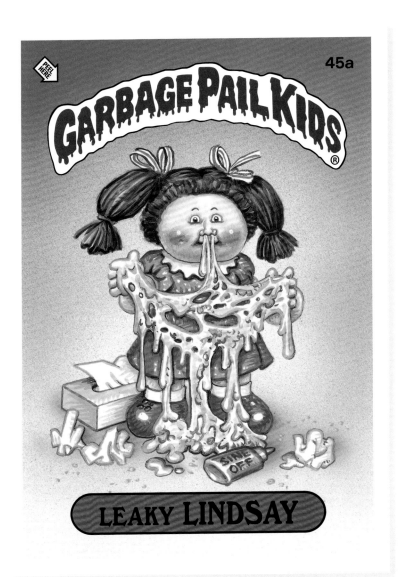

45a

GARBAGE PAIL KIDS®

LEAKY LINDSAY

MESSY TESSIE 45b

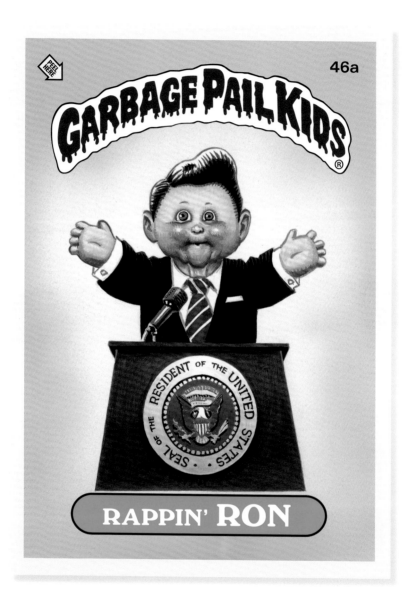

46a

GARBAGE PAIL KIDS®

RAPPIN' RON

RAY GUN 46b

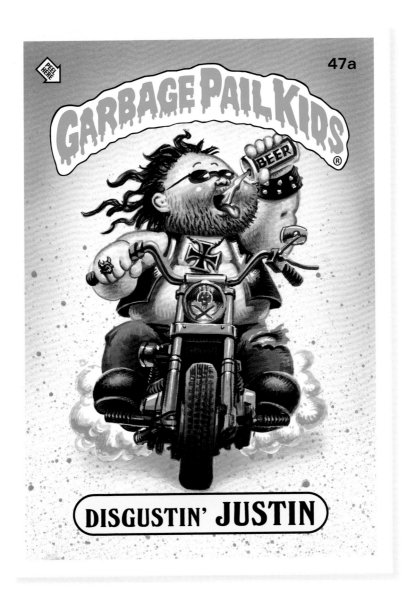

DISGUSTIN' JUSTIN

VILE KYLE 47b

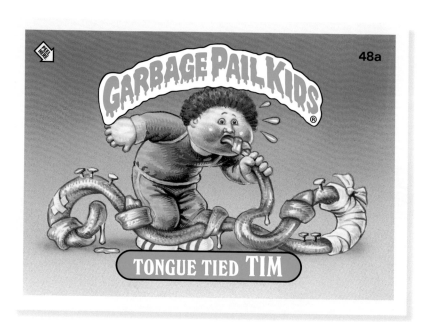

GARBAGE PAIL KIDS®

TONGUE TIED TIM

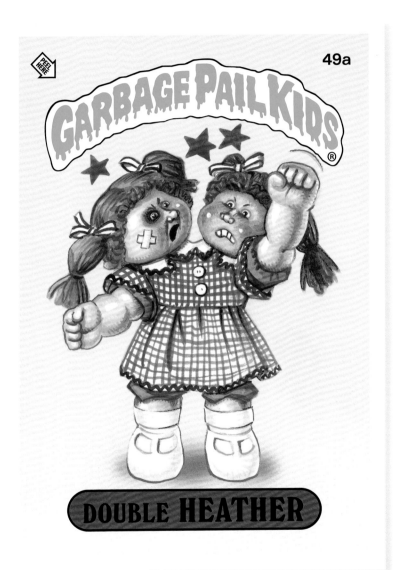

49a

GARBAGE PAIL KIDS

DOUBLE HEATHER

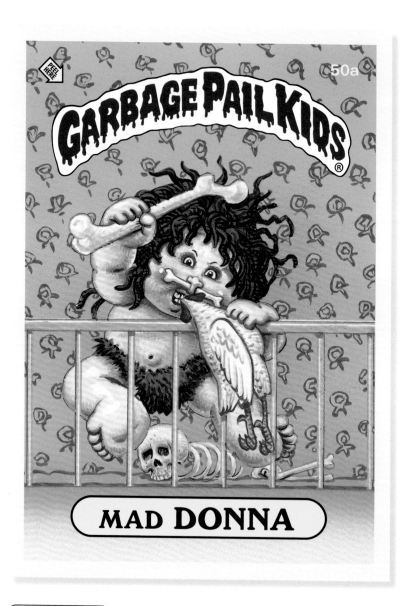

MAD **DONNA**

NUTTY **NICOLE** 50b

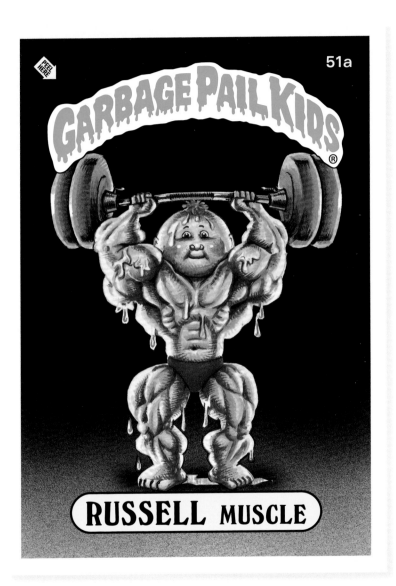

51a

RUSSELL MUSCLE

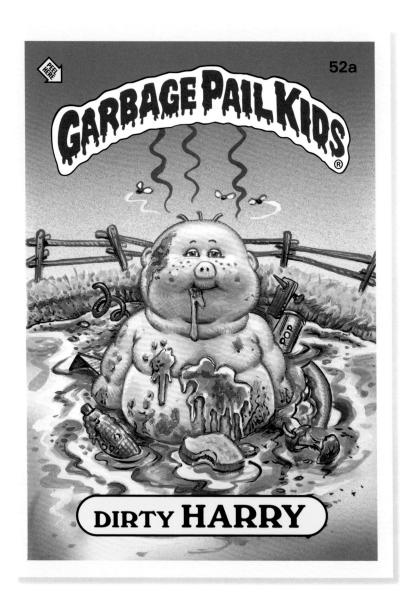

GARBAGE PAIL KIDS

52a

DIRTY **HARRY**

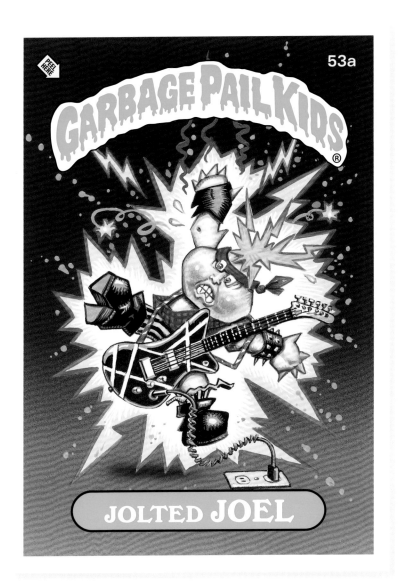

53a

GARBAGE PAIL KIDS ®

JOLTED JOEL

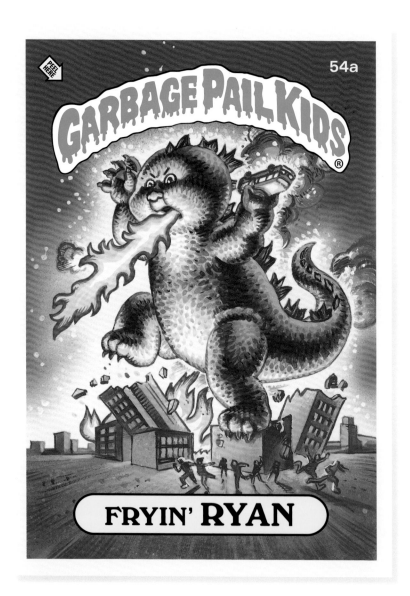

**GARBAGE PAIL KIDS**

54a

FRYIN' **RYAN**

CHARRED **CHAD** 54b

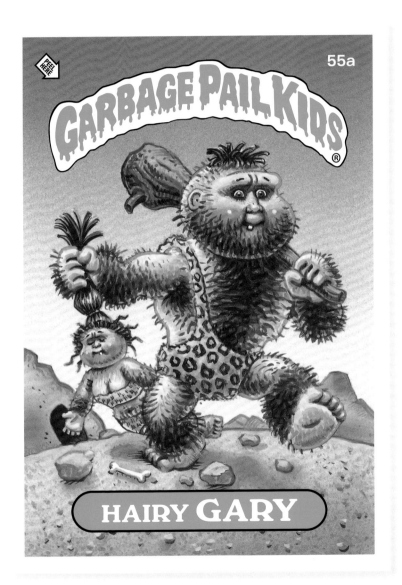

55a

GARBAGE PAIL KIDS®

HAIRY GARY

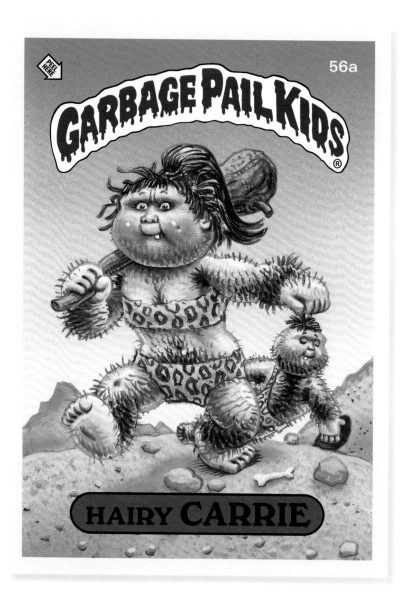

56a

GARBAGE PAIL KIDS

HAIRY CARRIE

BRUTAL BRIDGET 56b

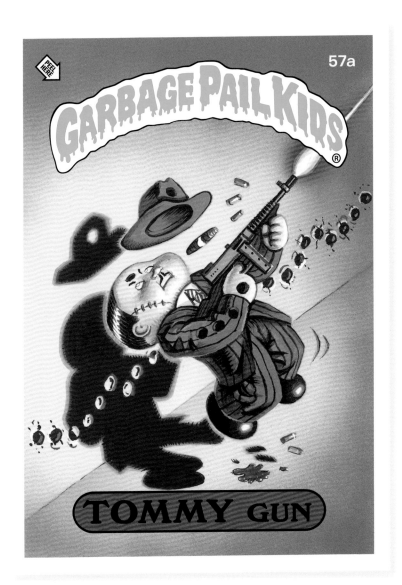

GARBAGE PAIL KIDS

57a

TOMMY GUN

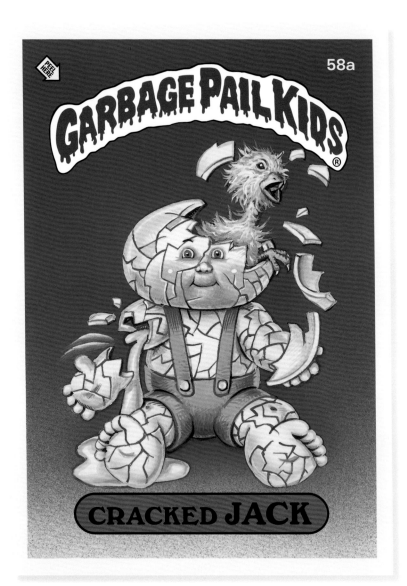

GARBAGE PAIL KIDS

58a

CRACKED **JACK**

SOFT BOILED SAM 58b

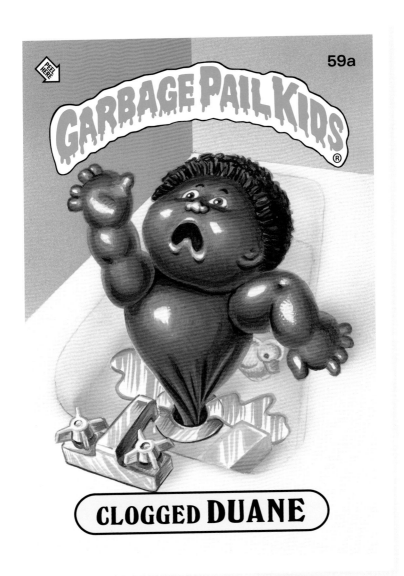

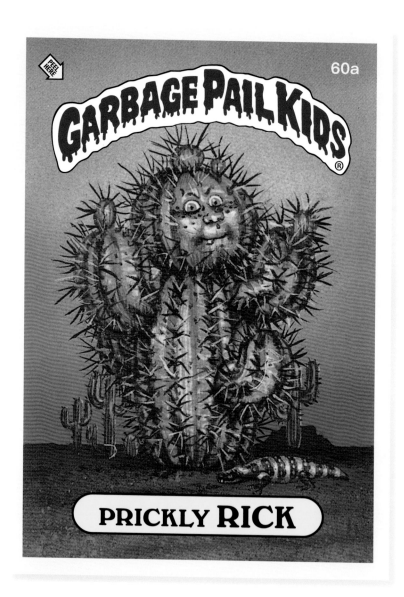

GARBAGE PAIL KIDS ®

PRICKLY **RICK**

CACTUS **CAROL** 60b

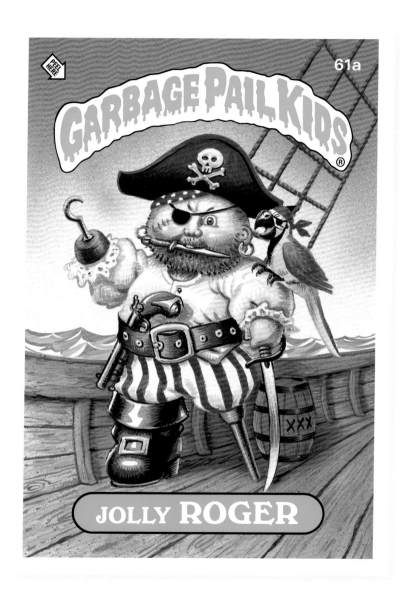

GARBAGE PAIL KIDS

JOLLY **ROGER**

61a

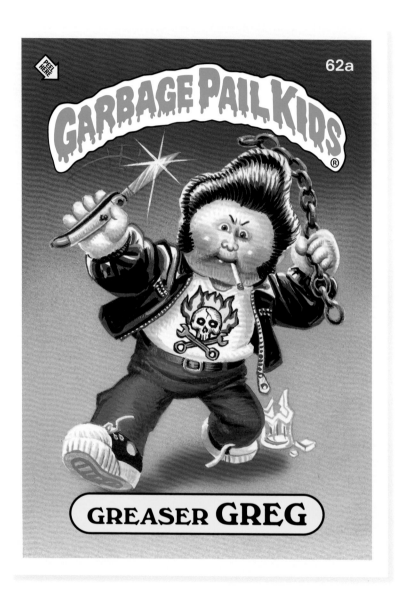

62a

GARBAGE PAIL KIDS ®

GREASER GREG

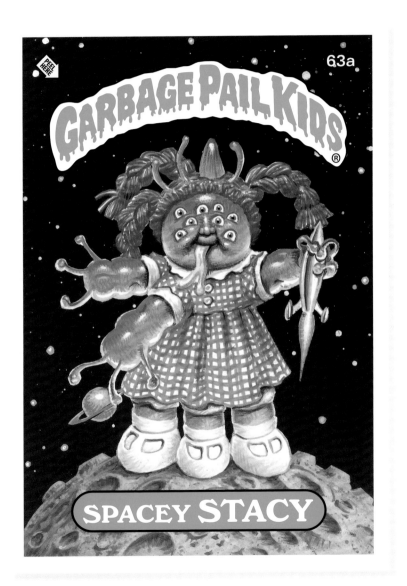

GARBAGE PAIL KIDS

63a

SPACEY STACY

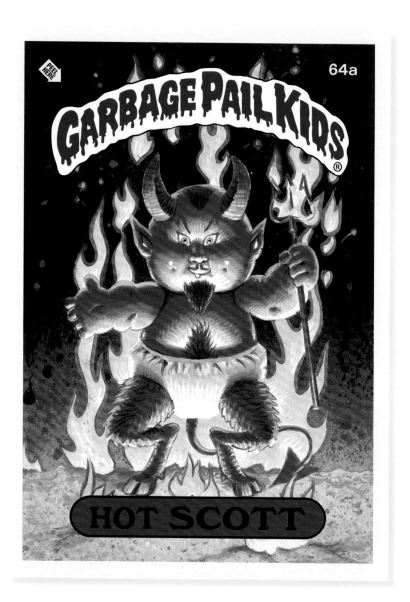

GARBAGE PAIL KIDS

HOT SCOTT

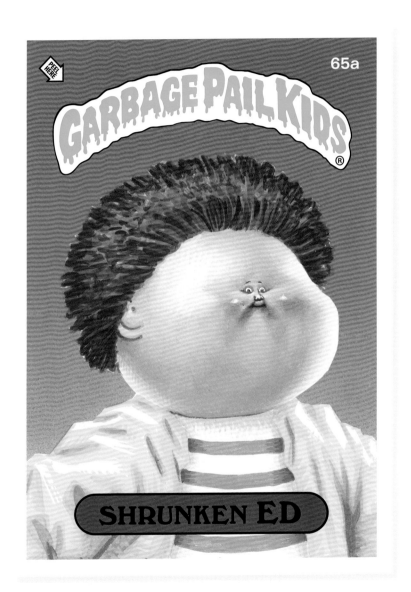

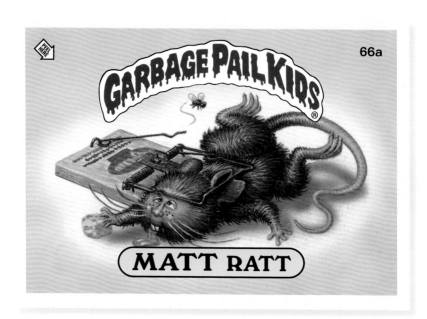

66a

MATT RATT

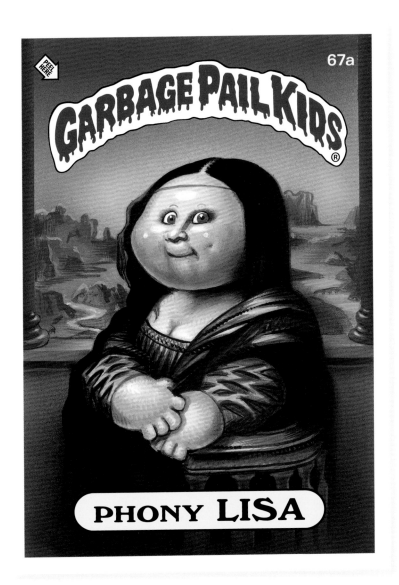

**67a**

GARBAGE PAIL KIDS®

PEEL HERE

PHONY **LISA**

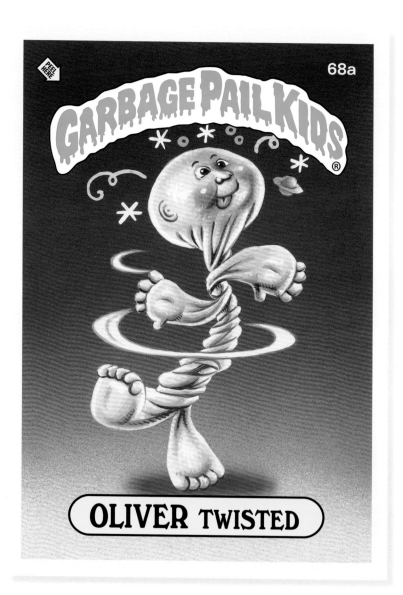

68a

OLIVER TWISTED

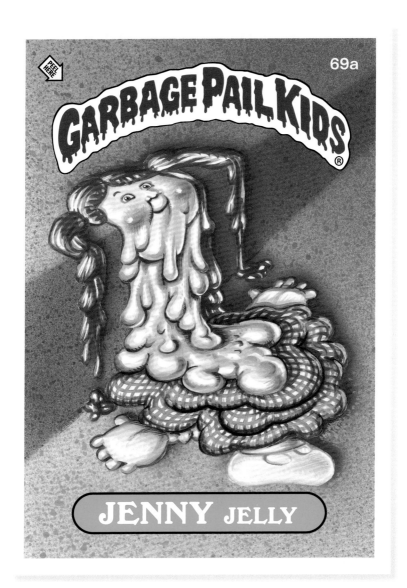

69a

JENNY JELLY

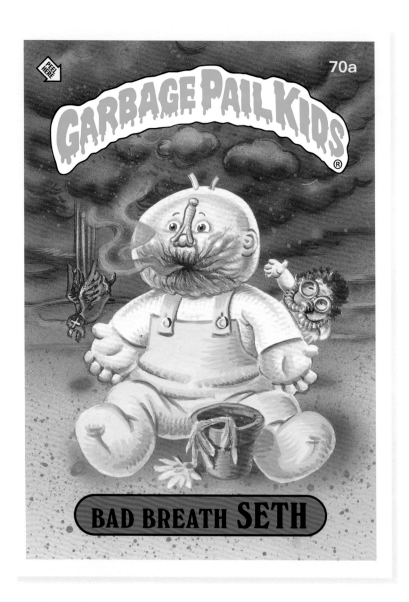

GARBAGE PAIL KIDS

BAD BREATH SETH

FOUL PHIL 70b

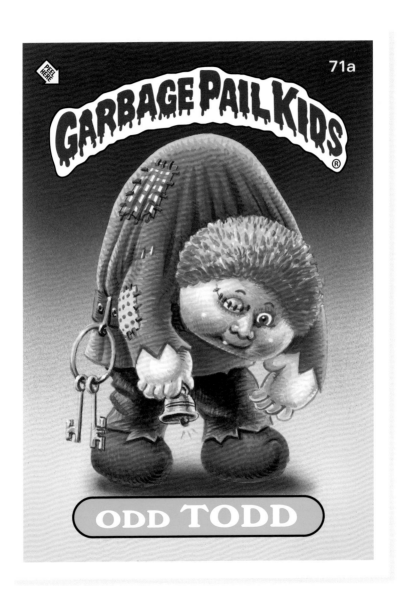

71a

GARBAGE PAIL KIDS®

ODD TODD

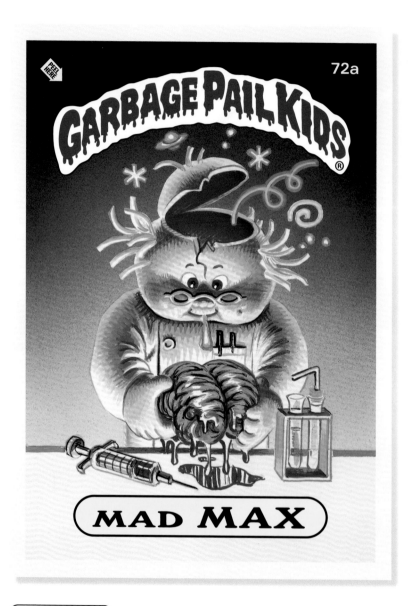

72a

# GARBAGE PAIL KIDS

## MAD MAX

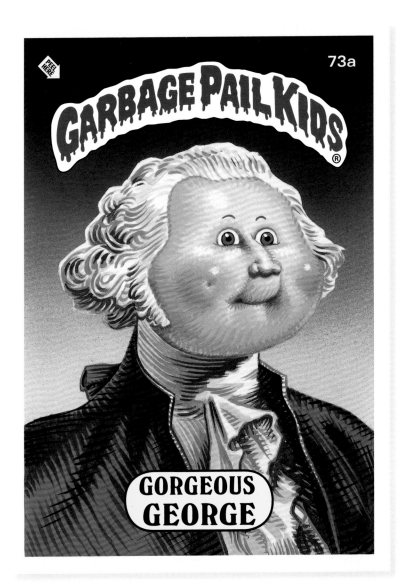

PEEL HERE

GARBAGE PAIL KIDS ®

GORGEOUS GEORGE

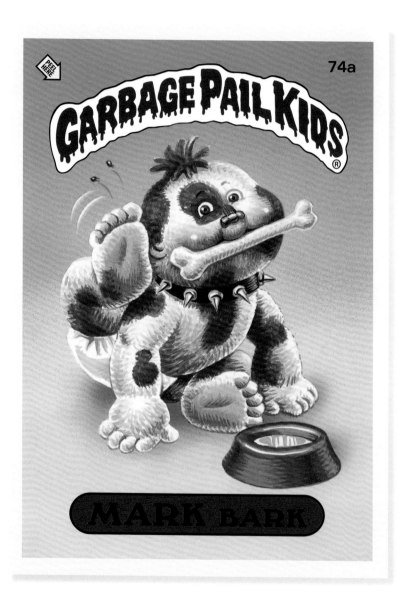

74a

GARBAGE PAIL KIDS®

MARK BARK

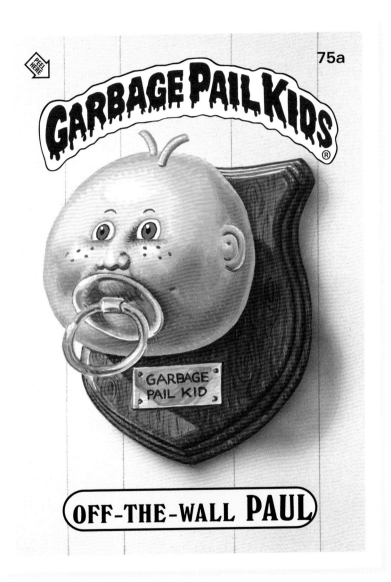

PEEL HERE

GARBAGE PAIL KIDS ®

GARBAGE PAIL KID

OFF-THE-WALL PAUL

ZACH PLAQUE 75b

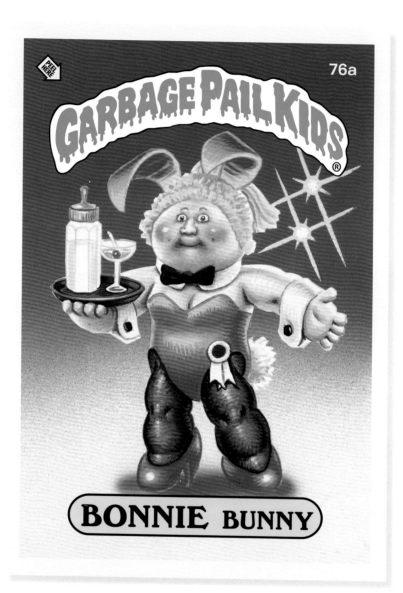

76a

GARBAGE PAIL KIDS ®

PEEL HERE

**BONNIE** BUNNY

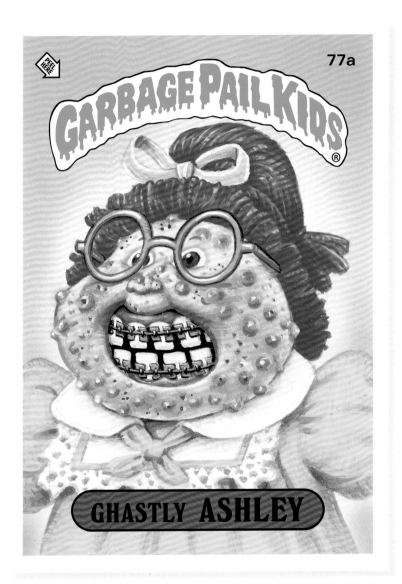

GARBAGE PAIL KIDS

77a

GHASTLY ASHLEY

ACNE AMY 77b

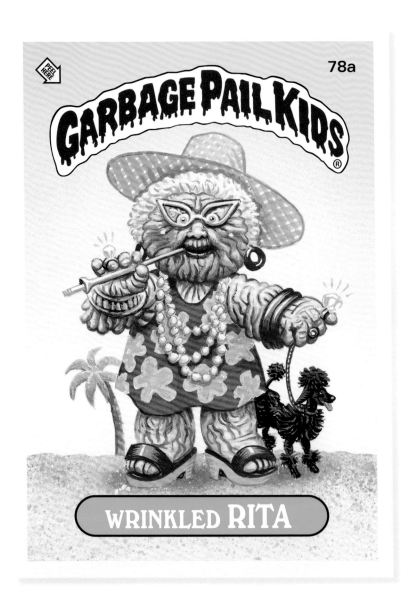

GARBAGE PAIL KIDS

WRINKLED **RITA**

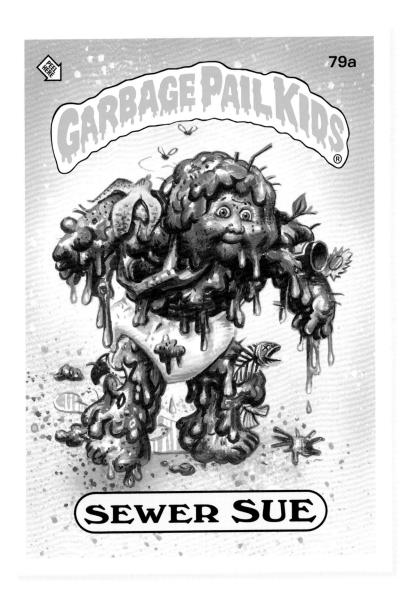

PEEL HERE

GARBAGE PAIL KIDS ®

SEWER SUE

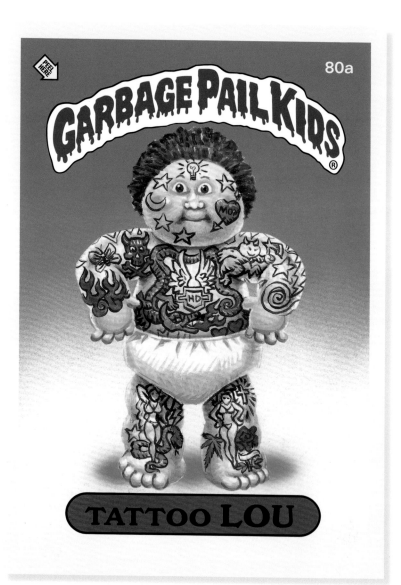

80a

GARBAGE PAIL KIDS®

TATTOO LOU

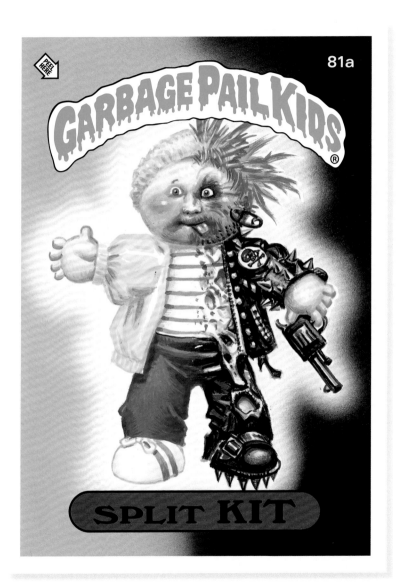

SPLIT KIT

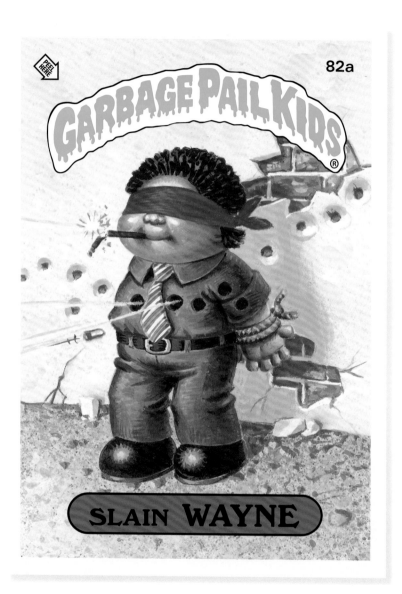

82a

GARBAGE PAIL KIDS

SLAIN **WAYNE**

VENTILATED VINNIE 82b

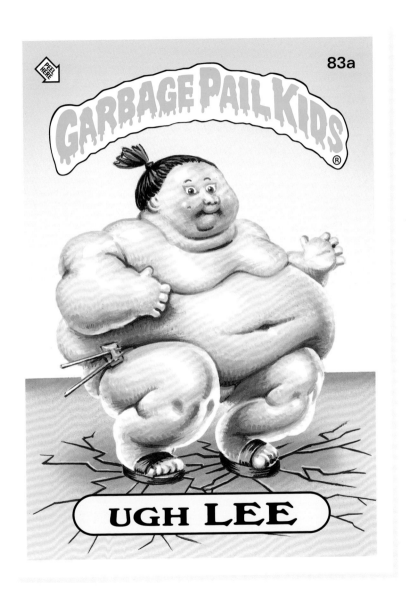

83a

GARBAGE PAIL KIDS

UGH LEE

SUMO SID 83b

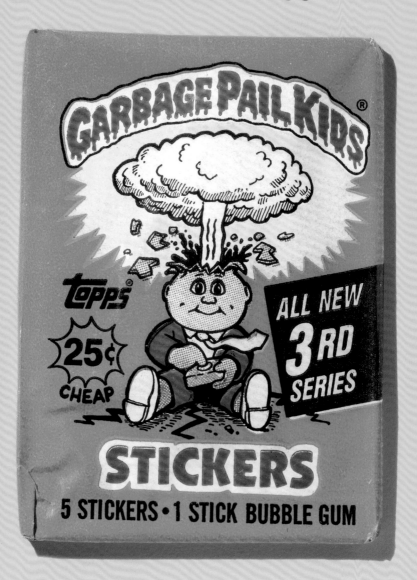

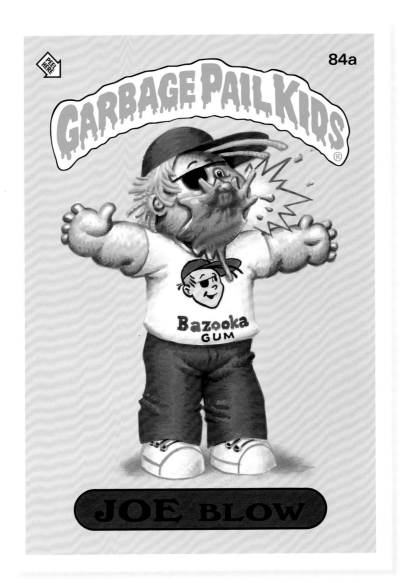

84a

GARBAGE PAIL KIDS®

Bazooka GUM

JOE BLOW

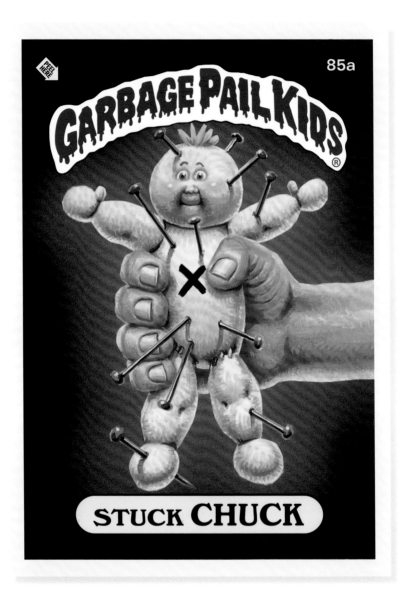

85a

GARBAGE PAIL KIDS

STUCK CHUCK

PINNED LYNN 85b

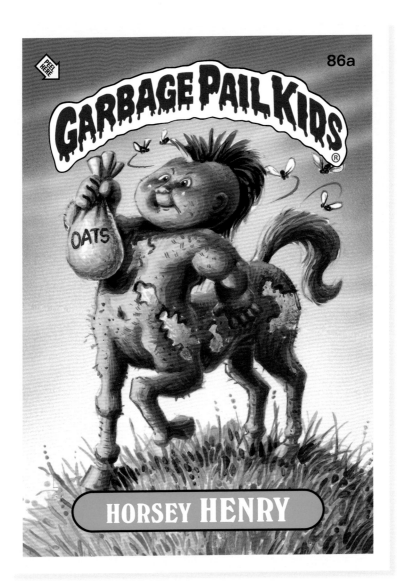

86a

GARBAGE PAIL KIDS

OATS

HORSEY **HENRY**

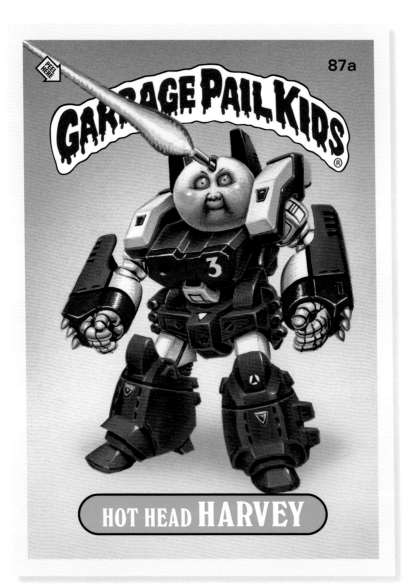

87a

GARBAGE PAIL KIDS

HOT HEAD **HARVEY**

ROY BOT  87b

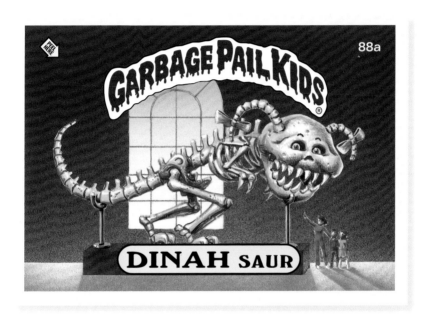

**DINAH SAUR**

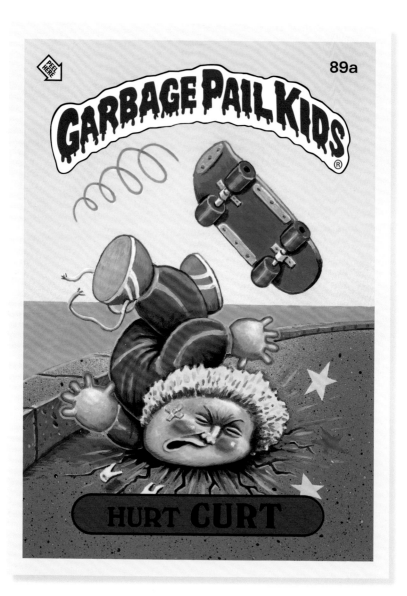

89a

GARBAGE PAIL KIDS

HURT CURT

PAT SPLAT 89b

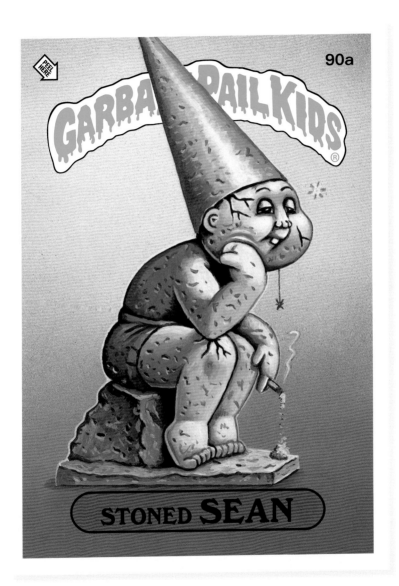

90a

GARBAGE PAILKIDS

STONED SEAN

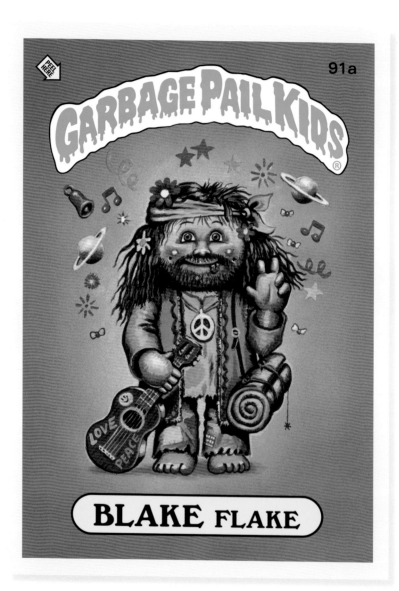

91a

GARBAGE PAIL KIDS

**BLAKE** FLAKE

HIPPIE **SKIPPY** 91b

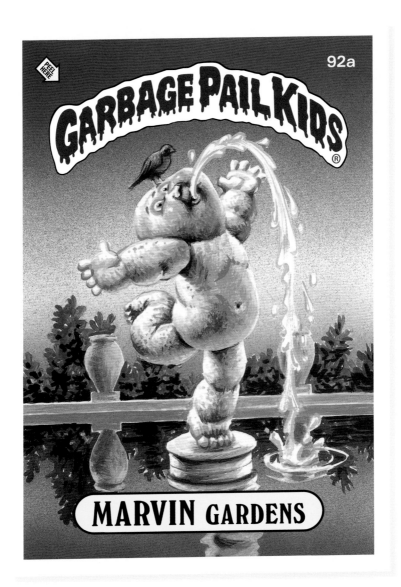

92a

GARBAGE PAIL KIDS ®

MARVIN GARDENS

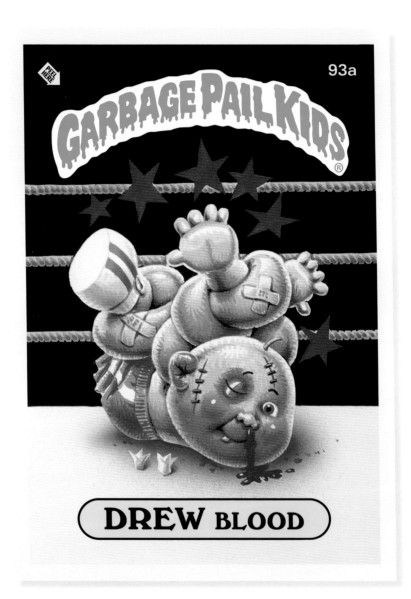

93a

GARBAGE PAIL KIDS

DREW BLOOD

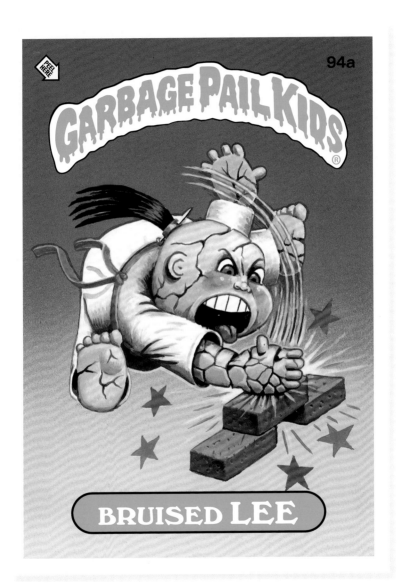

94a

GARBAGE PAIL KIDS

BRUISED **LEE**

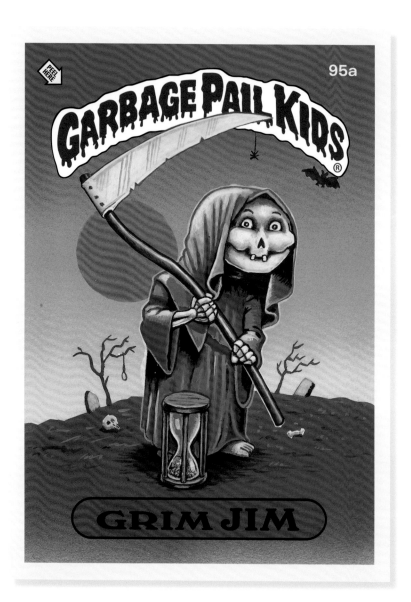

GARBAGE PAIL KIDS

95a

GRIM JIM

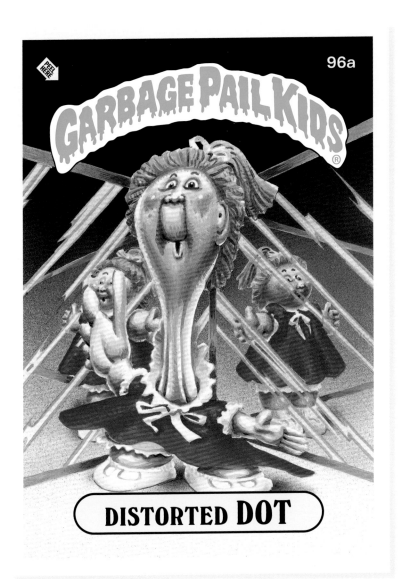

**DISTORTED DOT**

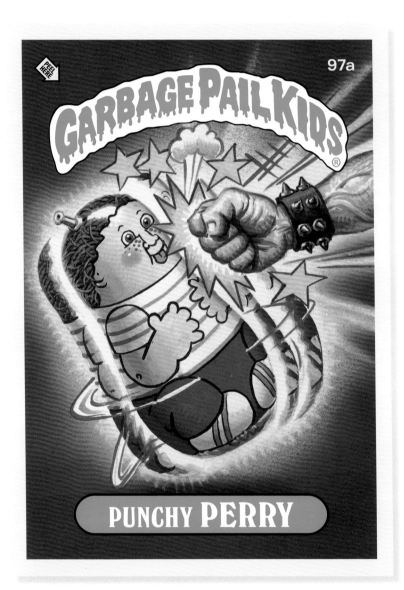

97a

GARBAGE PAIL KIDS

PUNCHY PERRY

CREAMED KEITH 97b

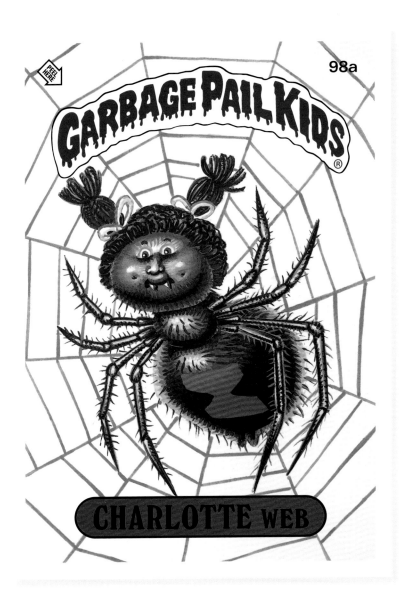

GARBAGE PAIL KIDS

CHARLOTTE WEB

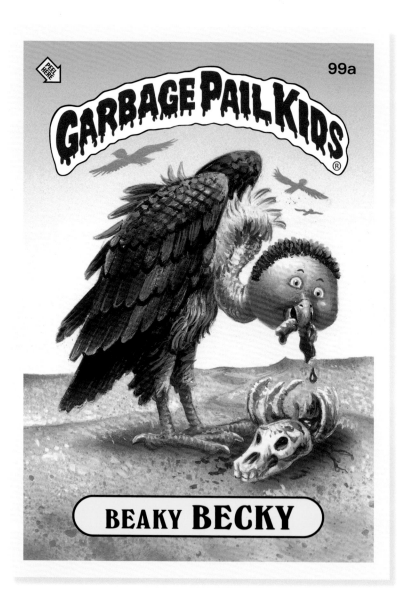

GARBAGE PAIL KIDS

BEAKY **BECKY**

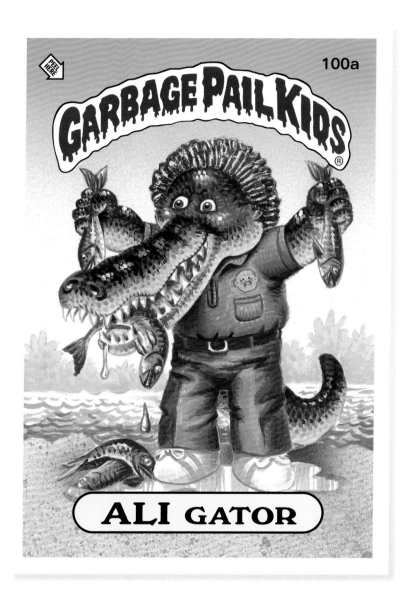

GARBAGE PAIL KIDS

100a

**ALI GATOR**

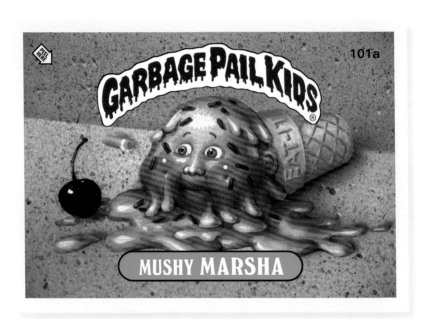

GARBAGE PAIL KIDS

101a

MUSHY **MARSHA**

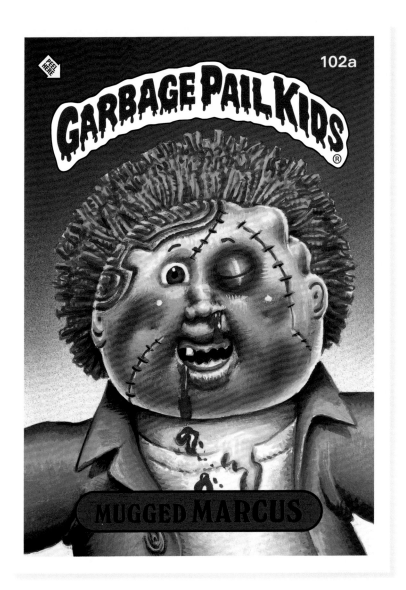

102a

GARBAGE PAIL KIDS ®

MUGGED MARCUS

KAYO'D CODY 102b

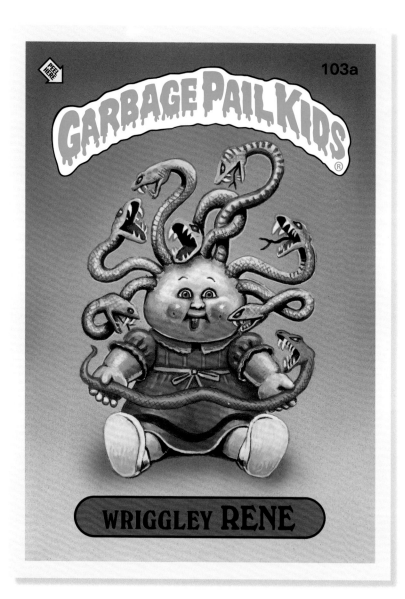

103a

GARBAGE PAIL KIDS

WRIGGLEY RENE

CURLY CARLA 103b

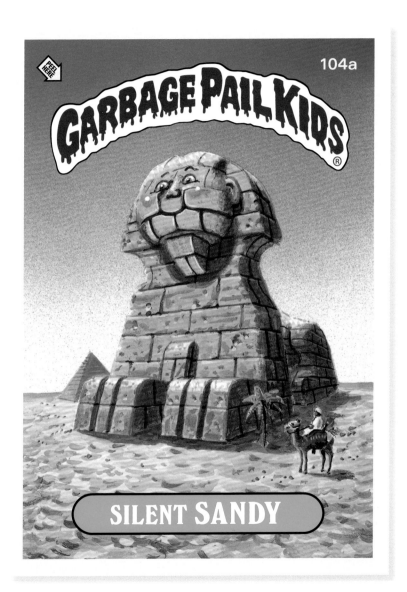

SILENT SANDY

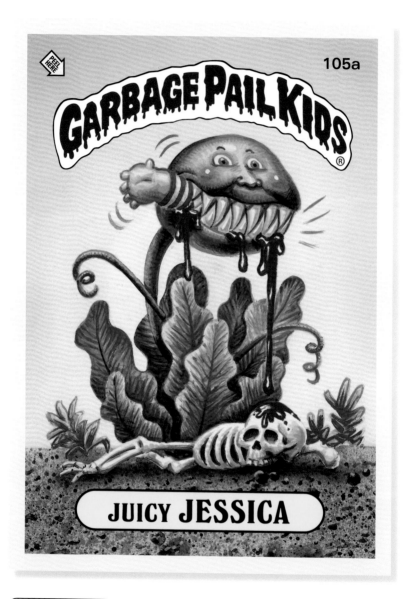

105a

GARBAGE PAIL KIDS ®

PEEL HERE

JUICY **JESSICA**

GREEN **DEAN** 105b

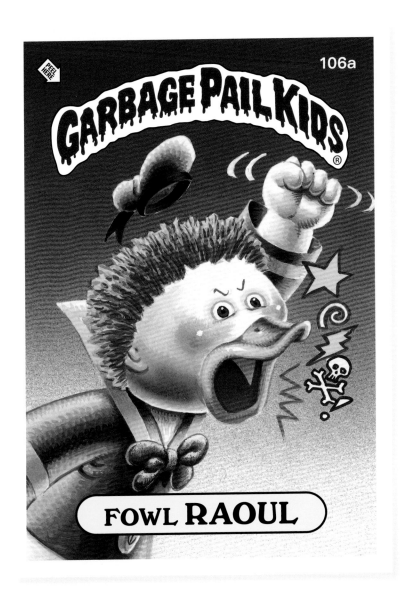

FOWL **RAOUL**

MACK QUACK 106b

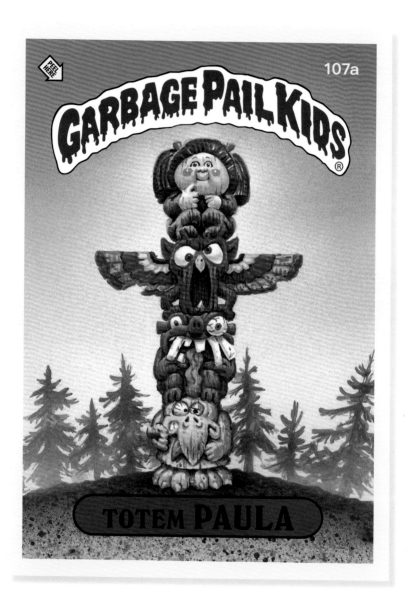

107a

# GARBAGE PAIL KIDS

®

TOTEM **PAULA**

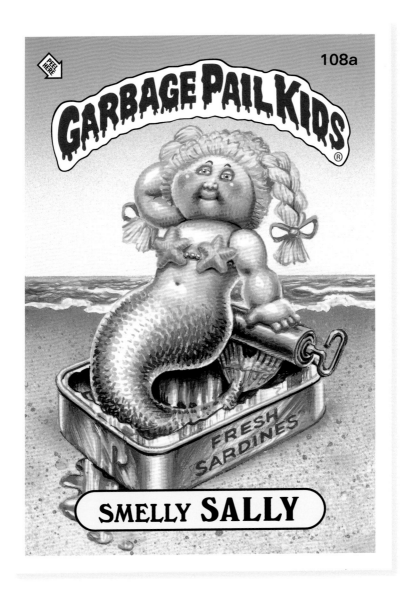

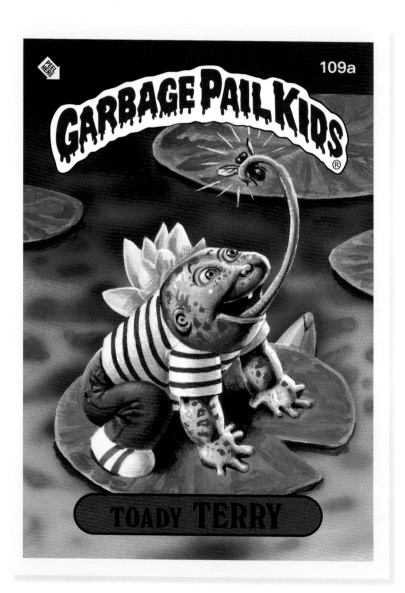

GARBAGE PAIL KIDS

109a

TOADY TERRY

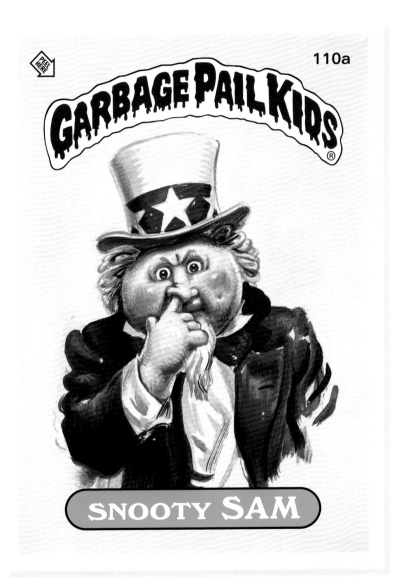

110a

# GARBAGE PAIL KIDS ®

SNOOTY SAM

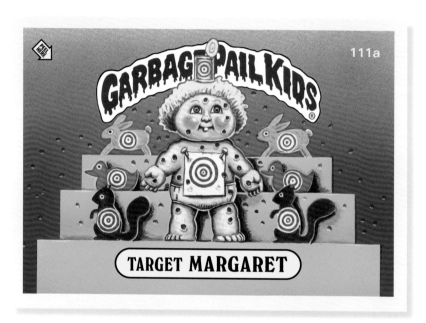

111a

TARGET MARGARET

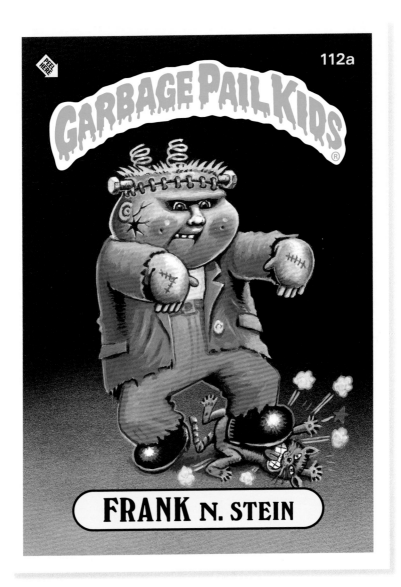

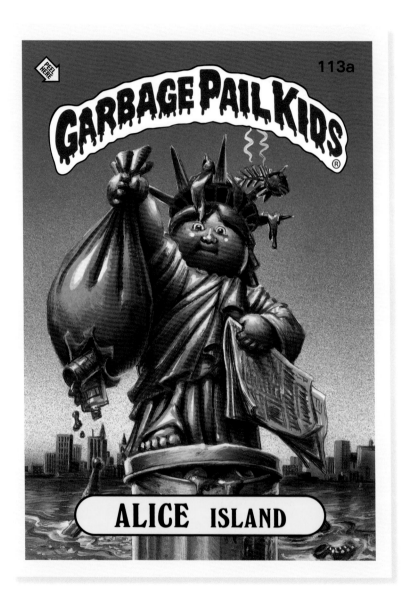

GARBAGE PAIL KIDS

113a

ALICE ISLAND

LIBERTY **LIBBY** 113b

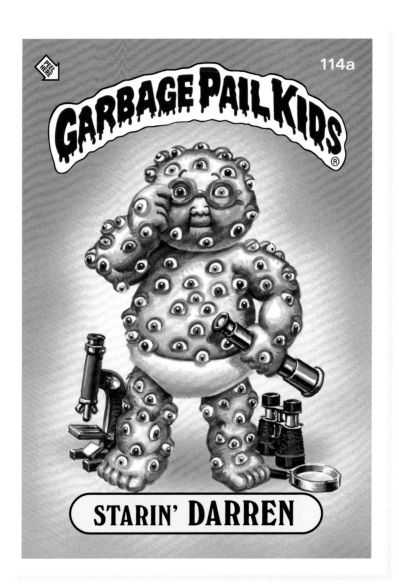

114a

GARBAGE PAIL KIDS

STARIN' DARREN

PEEPIN' **TOM** 114b

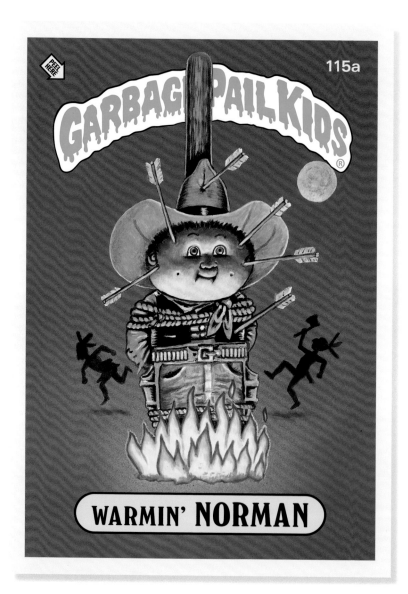

115a

GARBAGE PAIL KIDS

WARMIN' NORMAN

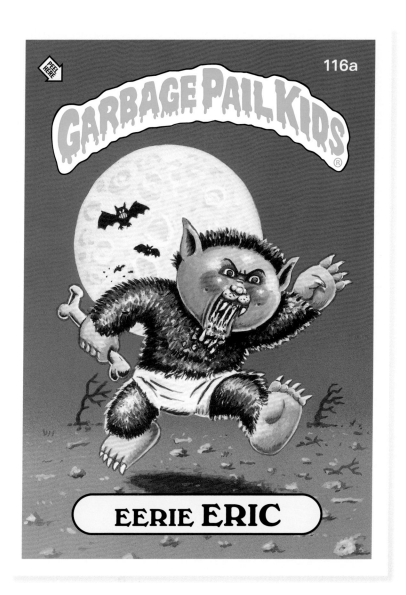

116a

GARBAGE PAIL KIDS ®

EERIE **ERIC**

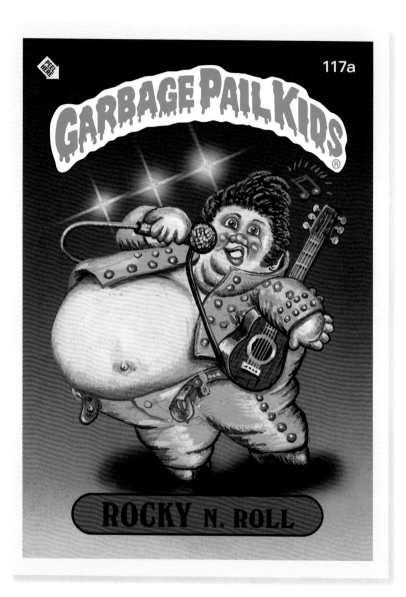

GARBAGE PAIL KIDS

117a

ROCKY N. ROLL

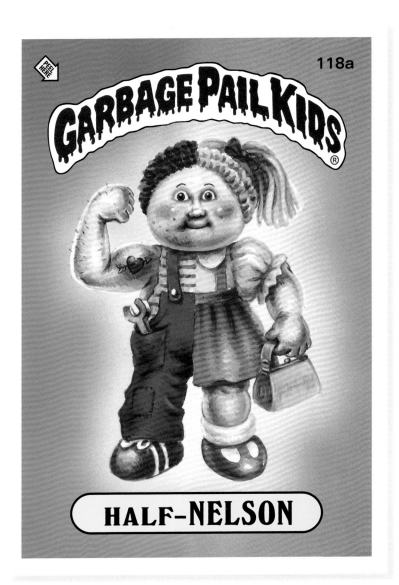

118a

GARBAGE PAIL KIDS

HALF-NELSON

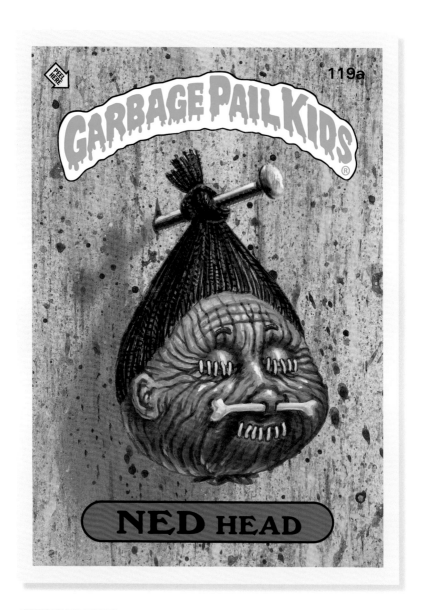

119a

GARBAGE PAIL KIDS

NED HEAD

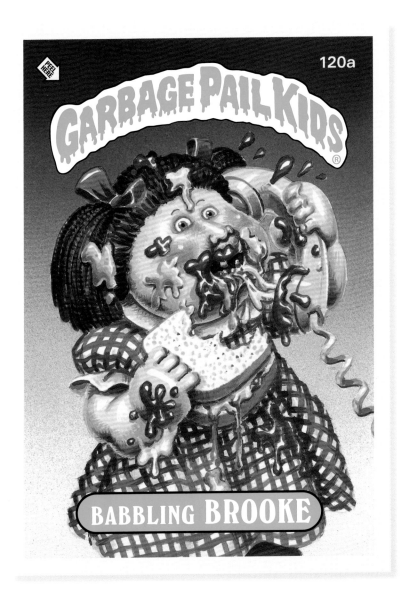

120a

GARBAGE PAIL KIDS

BABBLING **BROOKE**

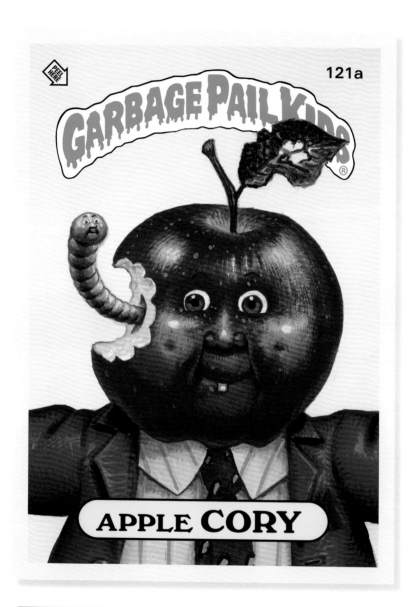

121a

GARBAGE PAIL KIDS

APPLE CORY

DWIGHT BITE 121b

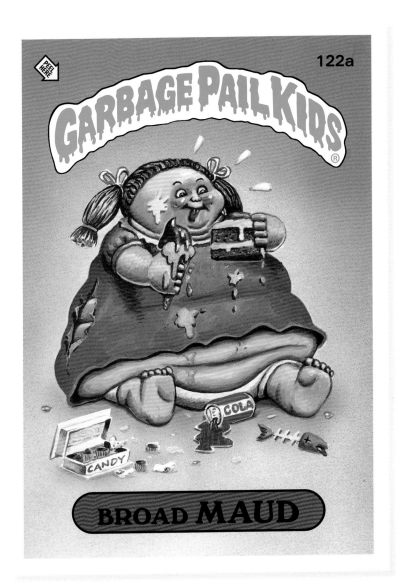

122a

GARBAGE PAIL KIDS

BROAD MAUD

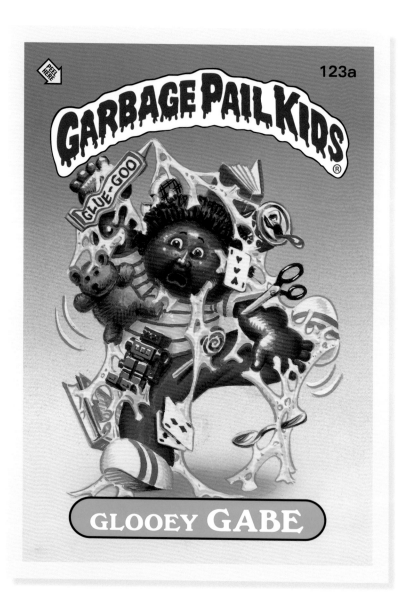

123a

# GARBAGE PAIL KIDS

®

GLUE-GOO

GLOOEY GABE

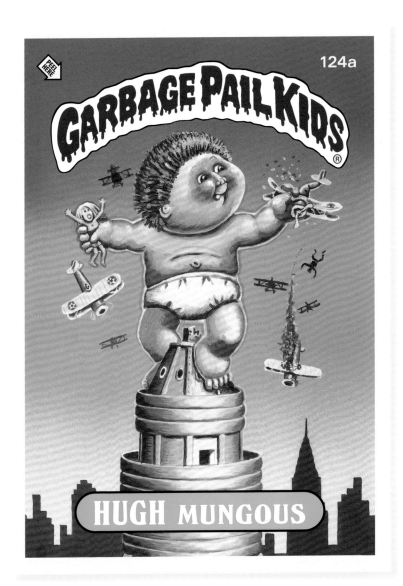

124a

GARBAGE PAIL KIDS

HUGH MUNGOUS

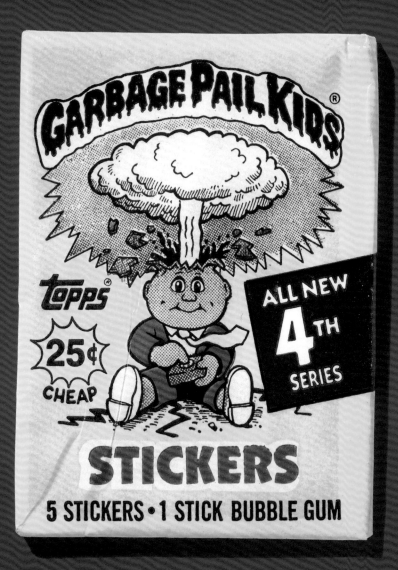

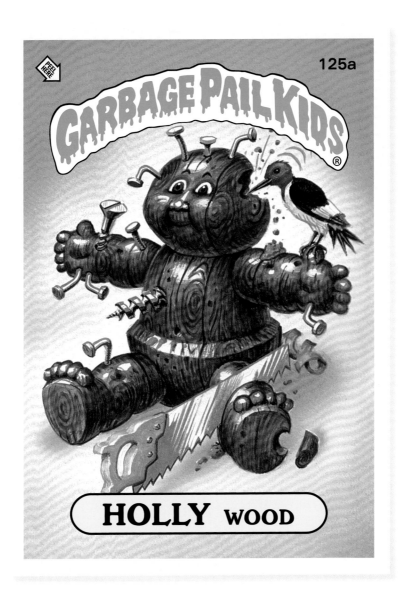

125a

GARBAGE PAIL KIDS ®

HOLLY WOOD

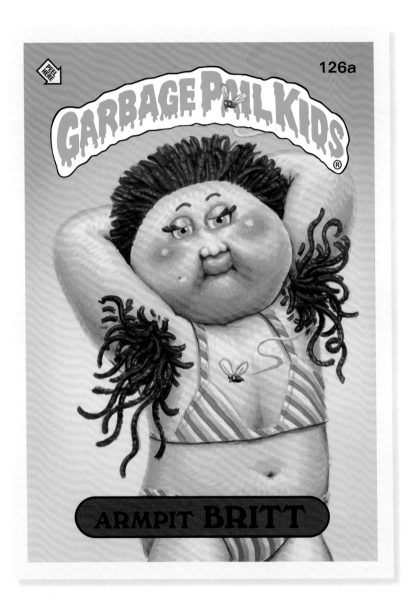

GARBAGE PAIL KIDS

126a

ARMPIT **BRITT**

SHAGGY **AGGIE** 126b

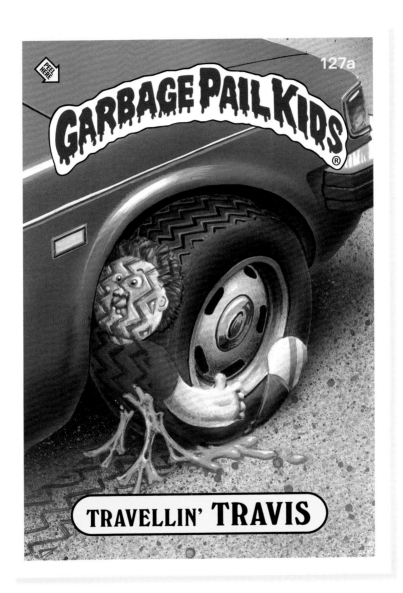

TRAVELLIN' **TRAVIS**

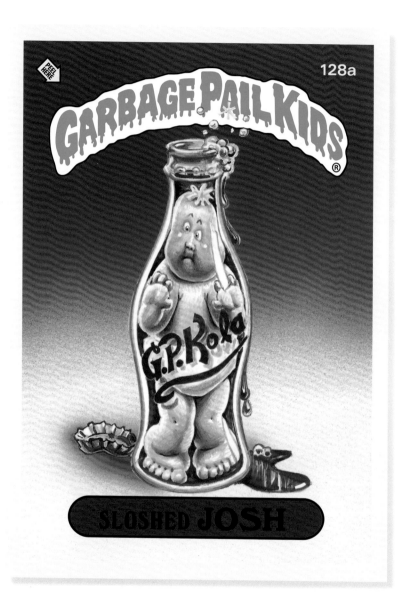

GARBAGE PAIL KIDS

SLOSHED JOSH

LOW CAL 128b

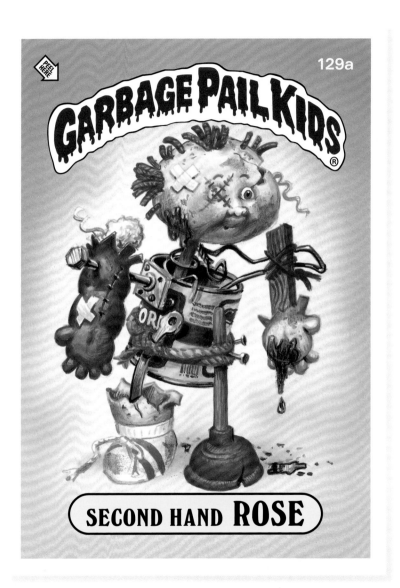

129a

GARBAGE PAIL KIDS®

SECOND HAND ROSE

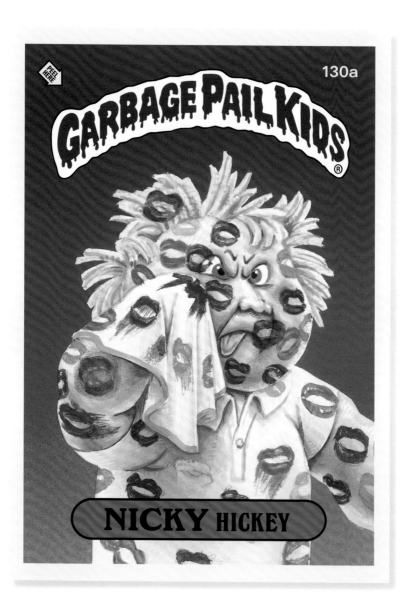

130a

GARBAGE PAIL KIDS®

NICKY HICKEY

HANK E. PANKY 130b

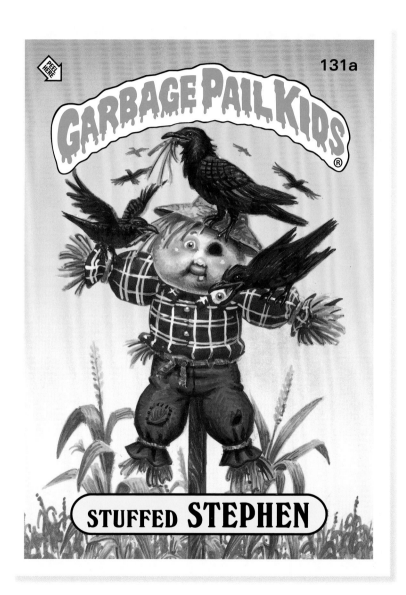

131a

GARBAGE PAIL KIDS

STUFFED **STEPHEN**

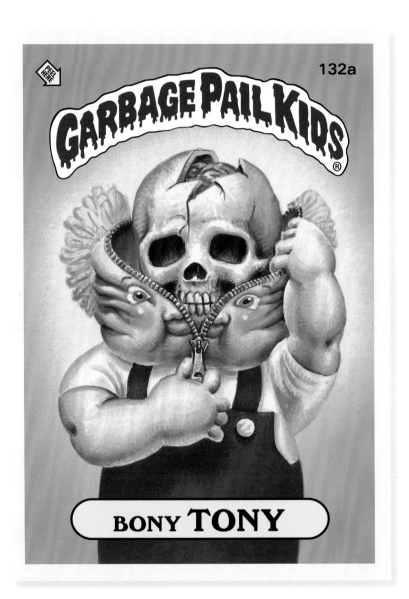

132a

# GARBAGE PAIL KIDS

PEEL HERE

BONY **TONY**

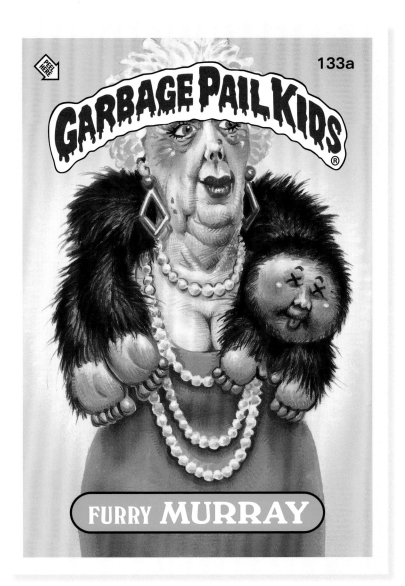

133a

GARBAGE PAIL KIDS

FURRY **MURRAY**

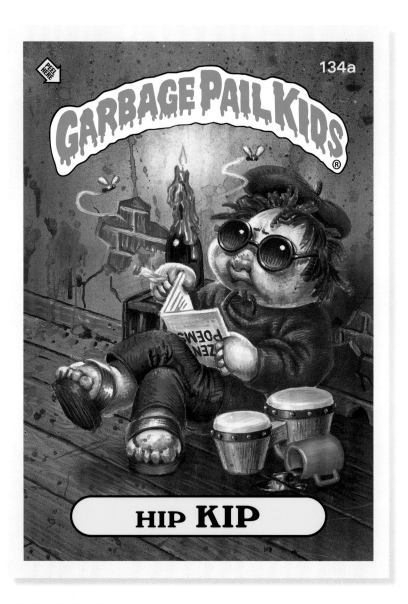

134a

GARBAGE PAIL KIDS

HIP **KIP**

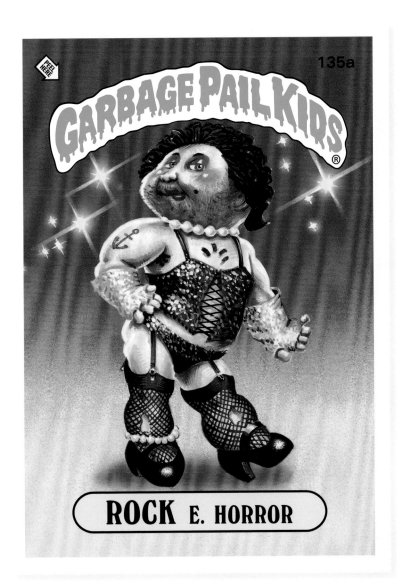

135a

GARBAGE PAIL KIDS®

ROCK E. HORROR

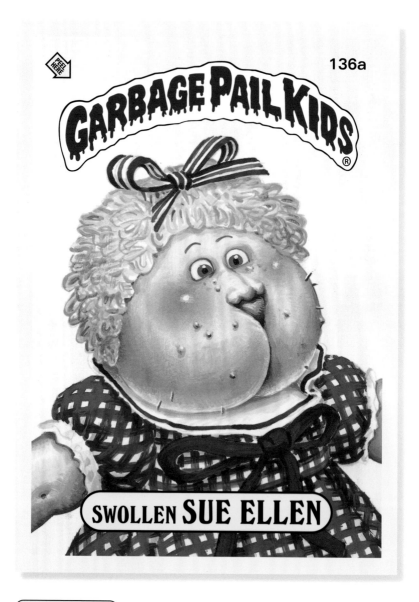

GARBAGE PAIL KIDS®

136a

SWOLLEN SUE ELLEN

BLOATED BLAIR 136b

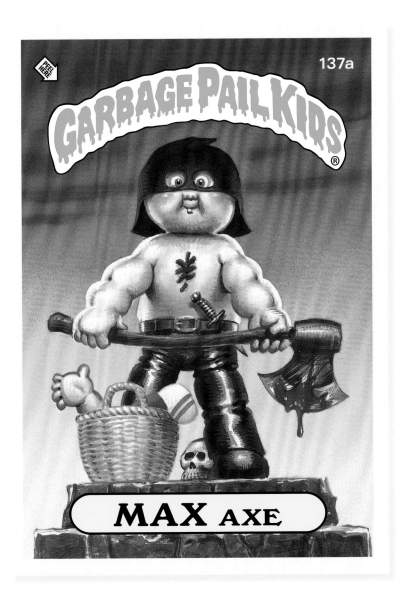

137a

GARBAGE PAIL KIDS ®

MAX AXE

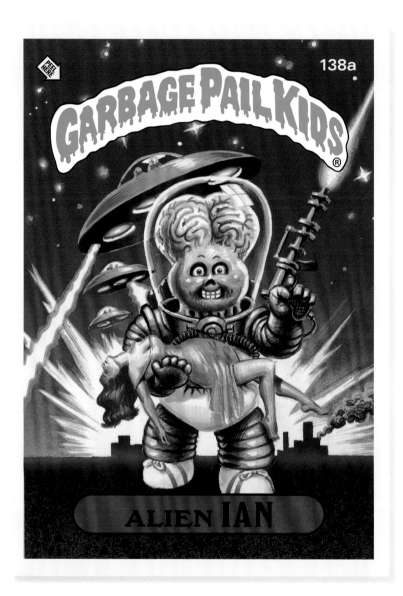

138a

GARBAGE PAIL KIDS

ALIEN IAN

OUTERSPACE CHASE 138b

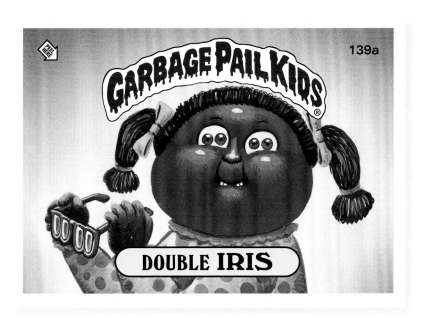

139a

GARBAGE PAIL KIDS ®

DOUBLE IRIS

4-EYED **IDA** 139b

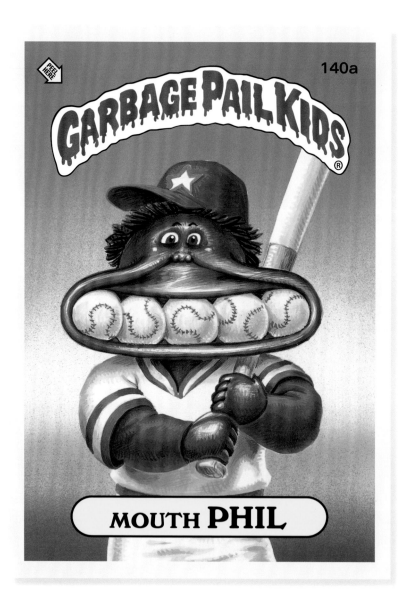

140a

GARBAGE PAIL KIDS

MOUTH PHIL

TOOTH LES 140b

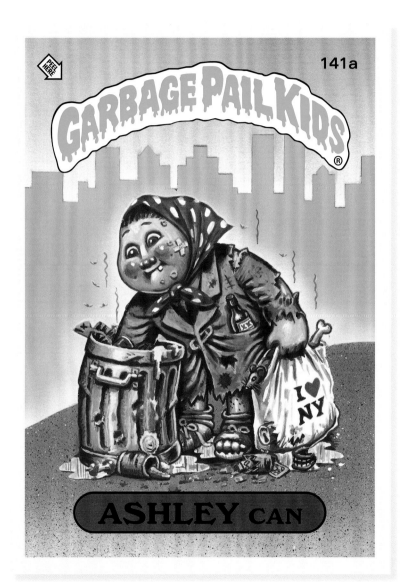

141a

GARBAGE PAIL KIDS

ASHLEY CAN

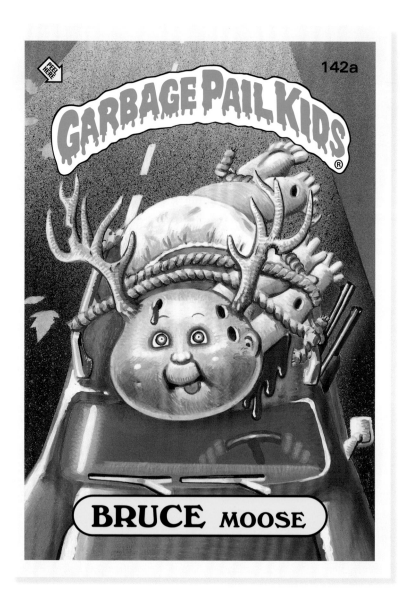

142a

GARBAGE PAIL KIDS ®

BRUCE MOOSE

HUNTED HUNTER 142b

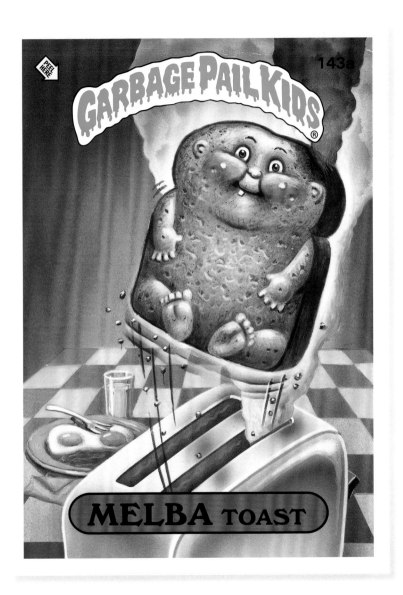

143a

GARBAGE PAIL KIDS®

MELBA TOAST

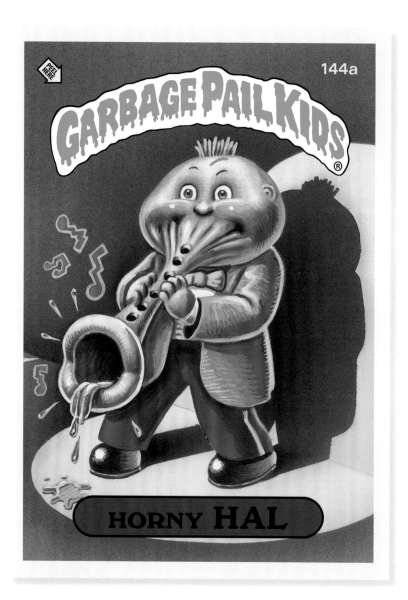

144a

GARBAGE PAIL KIDS

HORNY **HAL**

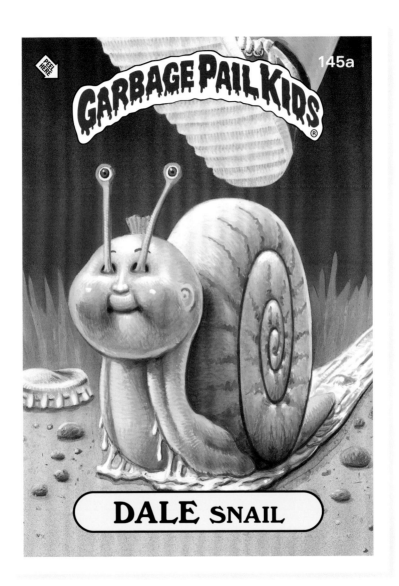

145a

DALE SNAIL

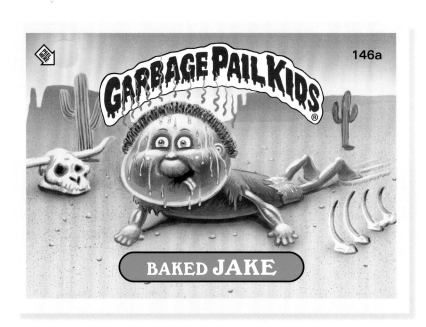

146a

**GARBAGE PAIL KIDS**®

BAKED JAKE

DRY GUY 146b

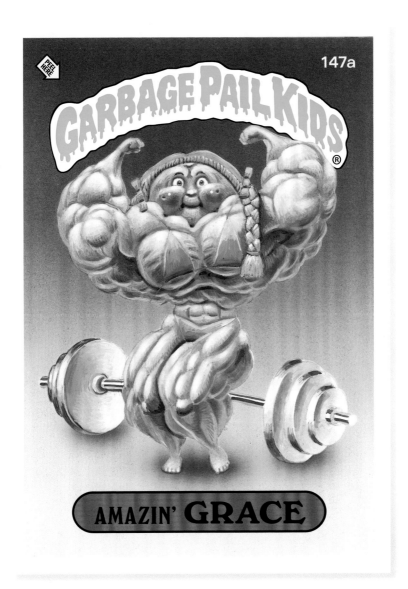

GARBAGE PAIL KIDS

147a

AMAZIN' GRACE

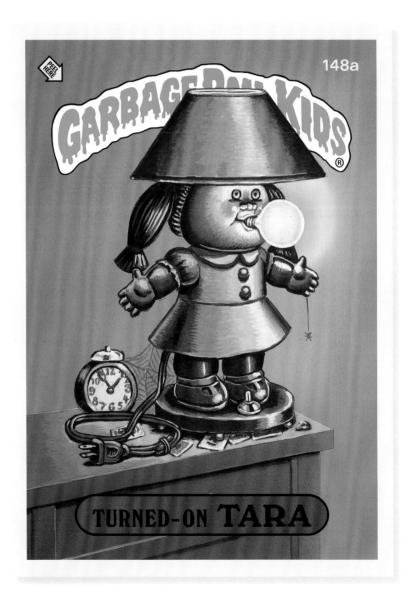

148a

GARBAGE PAIL KIDS®

TURNED-ON **TARA**

TIFFANY LAMP 148b

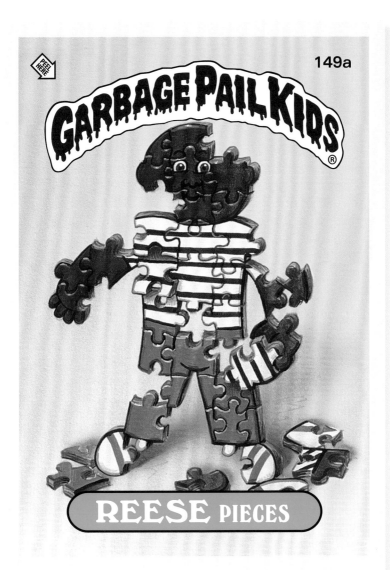

149a

# GARBAGE PAIL KIDS

## REESE PIECES

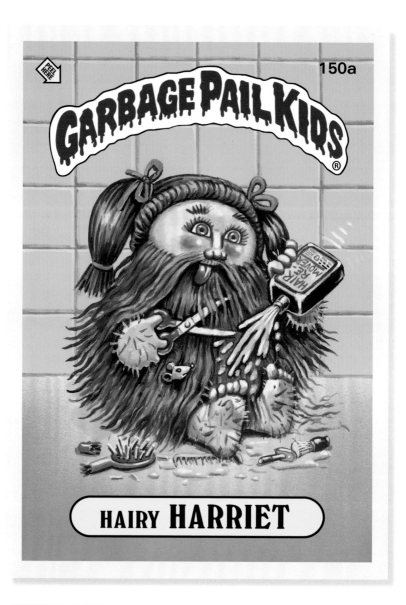

GARBAGE PAIL KIDS

150a

PEEL HERE

®

HAIRY **HARRIET**

BUSHY **BERNICE** 150b

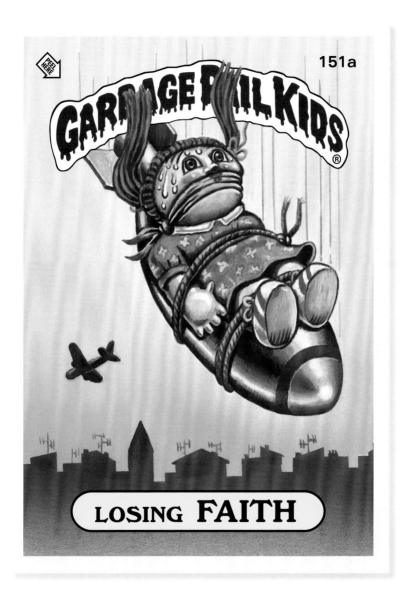

151a

GARBAGE PAIL KIDS

LOSING **FAITH**

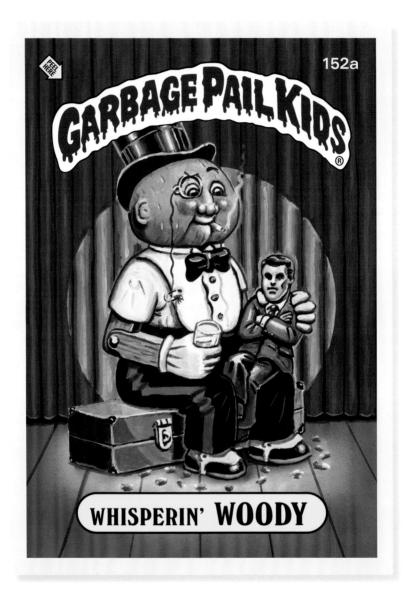

152a

# GARBAGE PAIL KIDS

## WHISPERIN' **WOODY**

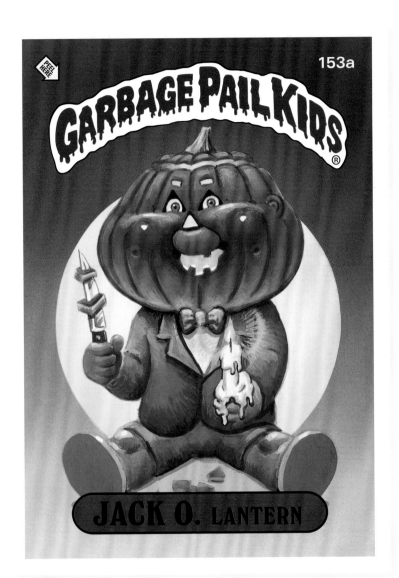

GARBAGE PAIL KIDS

153a

JACK O. LANTERN

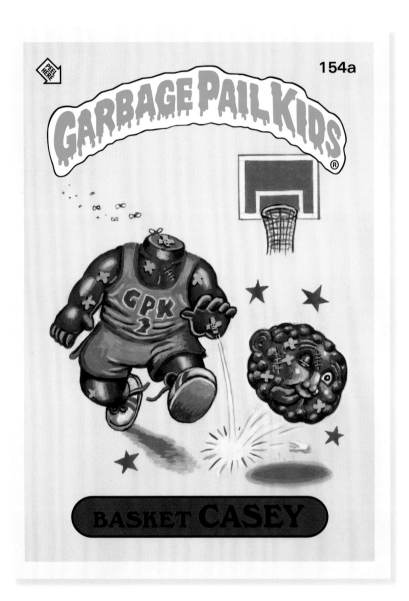

154a

BASKET CASEY

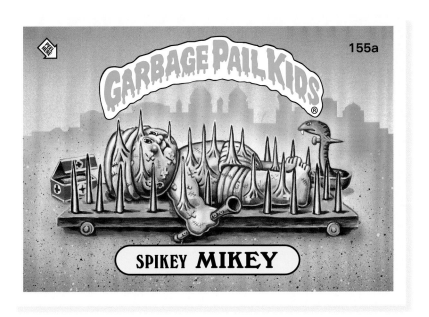

155a

GARBAGE PAIL KIDS

SPIKEY MIKEY

NAILED NEIL 155b

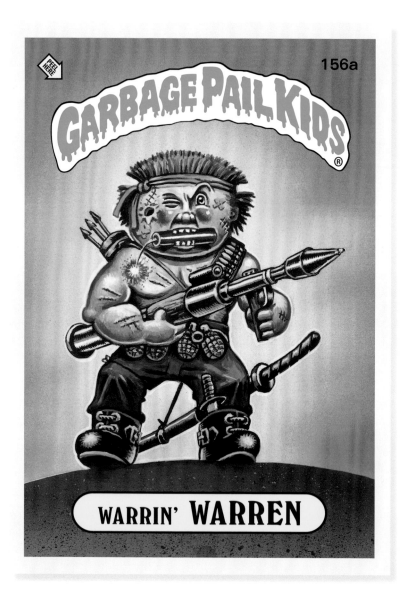

156a

GARBAGE PAIL KIDS

®

WARRIN' WARREN

BRETT VET 156b

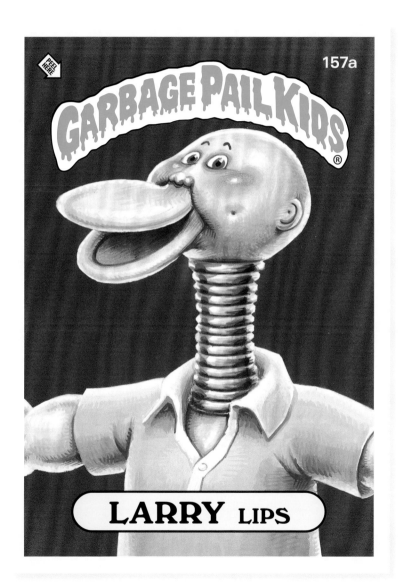

157a

**GARBAGE PAIL KIDS**

**LARRY** LIPS

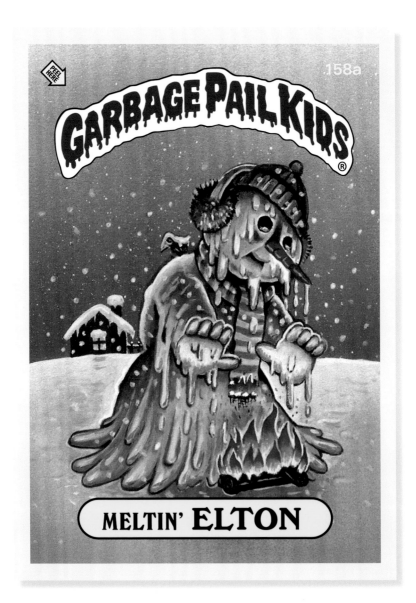

GARBAGE PAIL KIDS

158a

MELTIN' **ELTON**

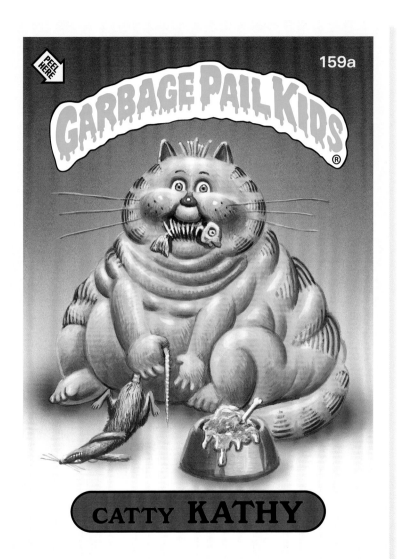

159a

GARBAGE PAIL KIDS

CATTY **KATHY**

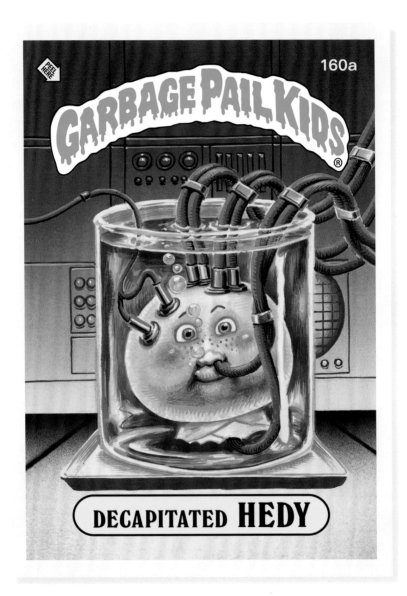

160a

GARBAGE PAIL KIDS®

DECAPITATED **HEDY**

FORMALDE **HEIDI** 160b

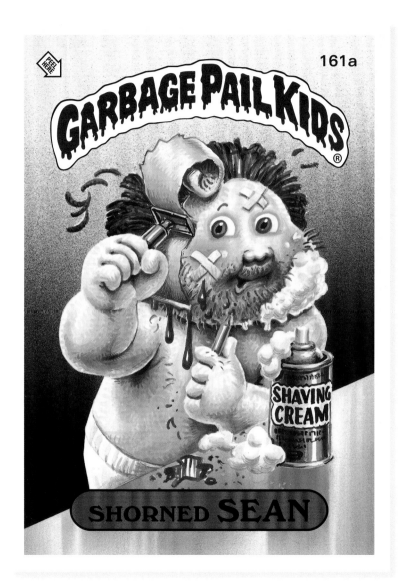

161a

GARBAGE PAIL KIDS

SHAVING CREAM

SHORNED SEAN

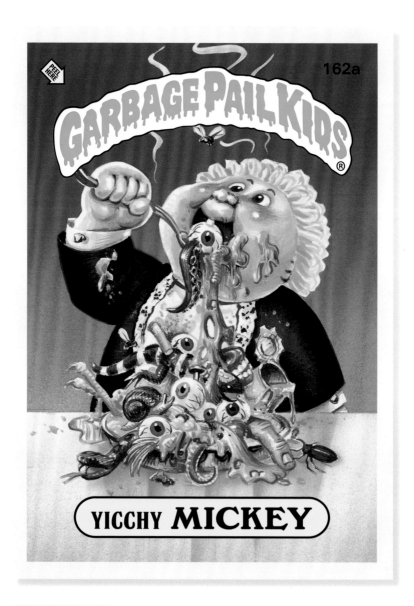

162a

GARBAGE PAIL KIDS

YICCHY **MICKEY**

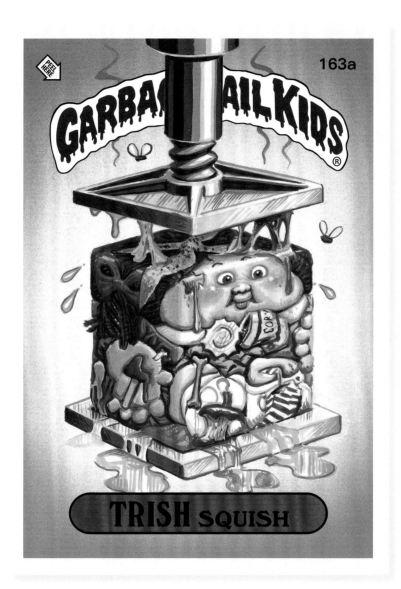

163a

GARBAGE PAIL KIDS

TRISH SQUISH

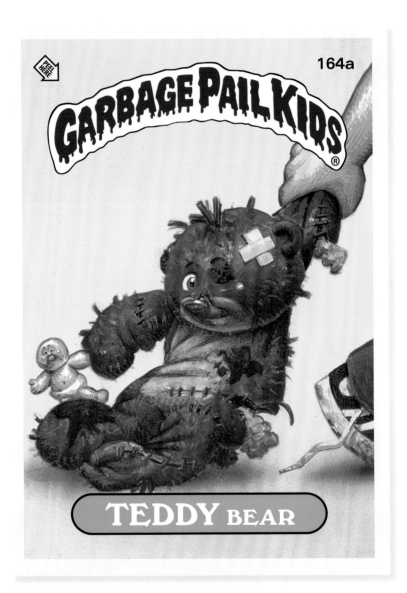

164a

# GARBAGE PAIL KIDS ®

## TEDDY BEAR

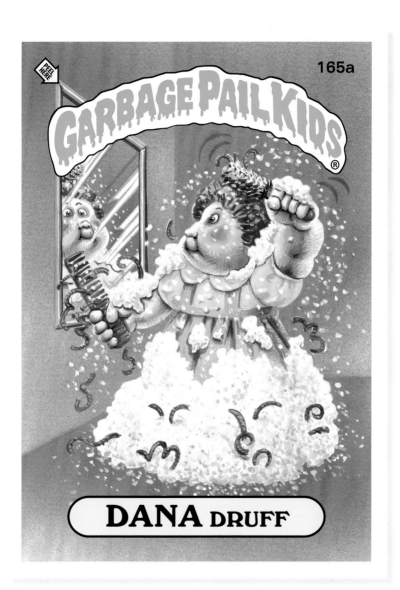

165a

GARBAGE PAIL KIDS®

DANA DRUFF

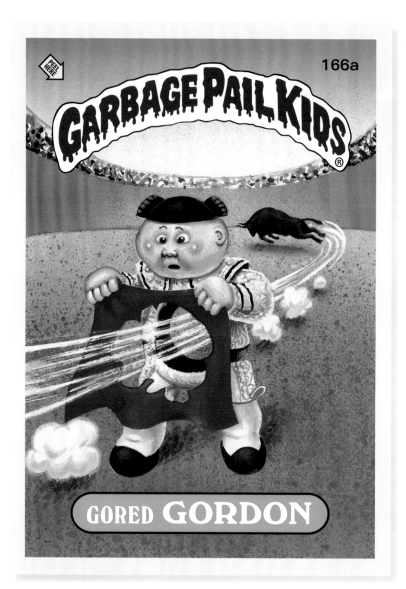

166a

GARBAGE PAIL KIDS

GORED **GORDON**

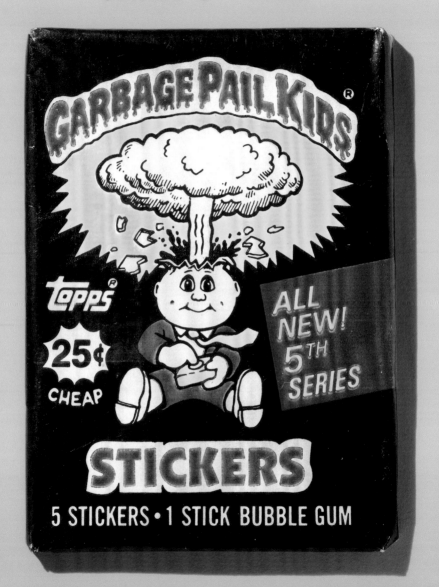

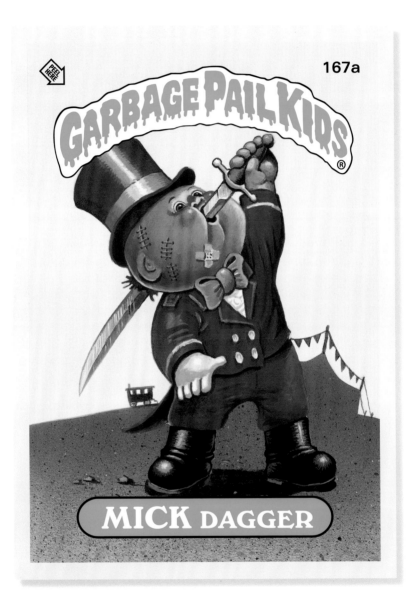

167a

GARBAGE PAIL KIDS

MICK DAGGER

SLAYED SLADE 167b

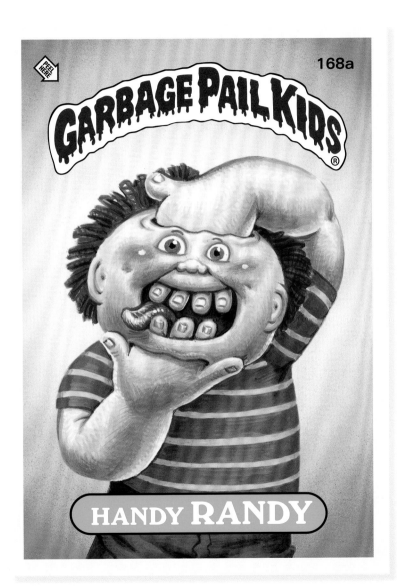

168a

GARBAGE PAIL KIDS ®

HANDY RANDY

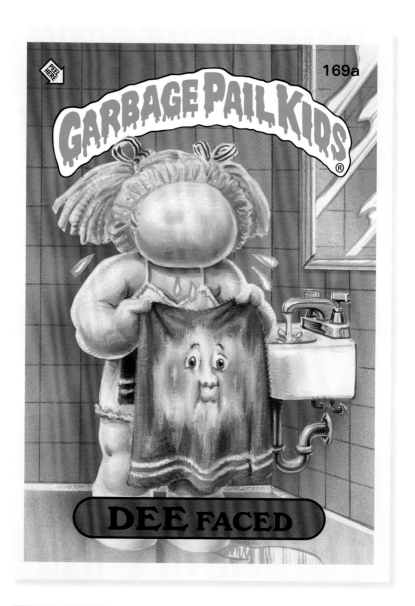

169a

GARBAGE PAIL KIDS

DEE FACED

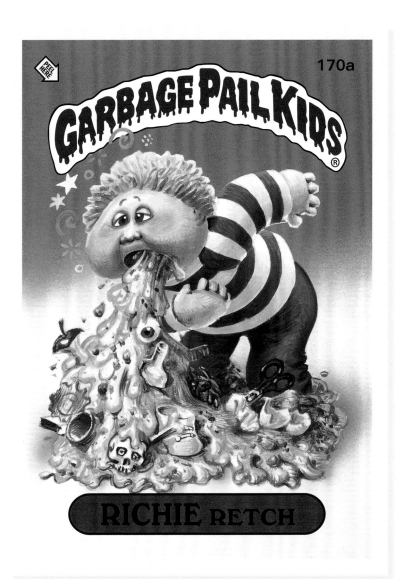

170a

GARBAGE PAIL KIDS®

RICHIE RETCH

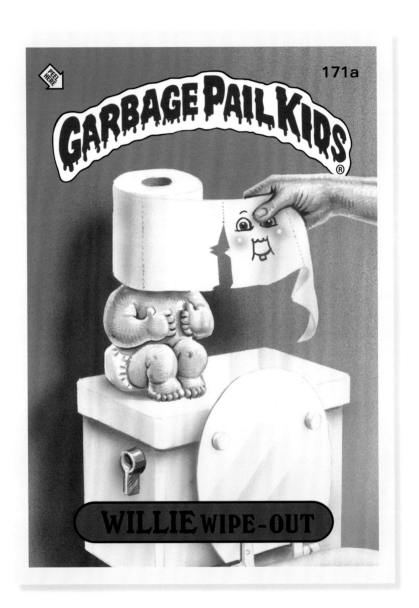

171a

GARBAGE PAIL KIDS

**WILLIE WIPE-OUT**

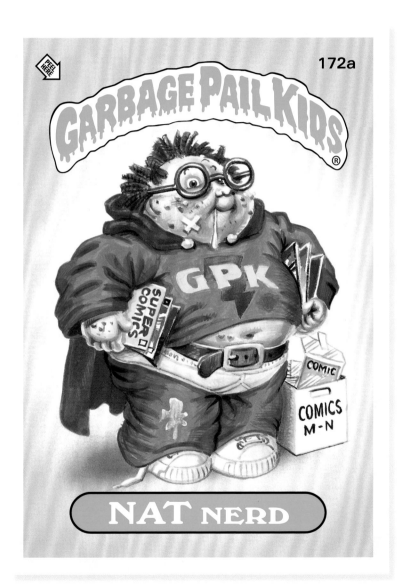

172a

GARBAGE PAIL KIDS

NAT NERD

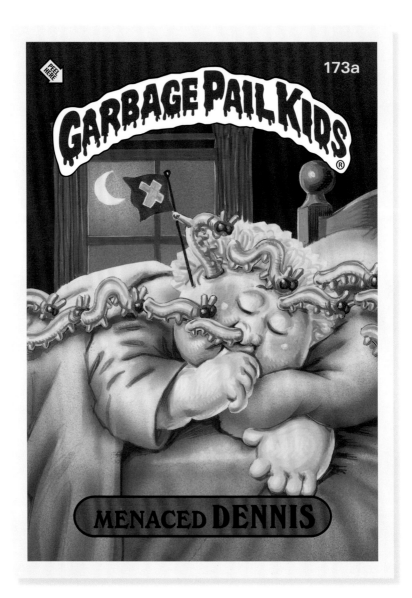

173a

GARBAGE PAIL KIDS

MENACED **DENNIS**

WORMY **SHERMY** 173b

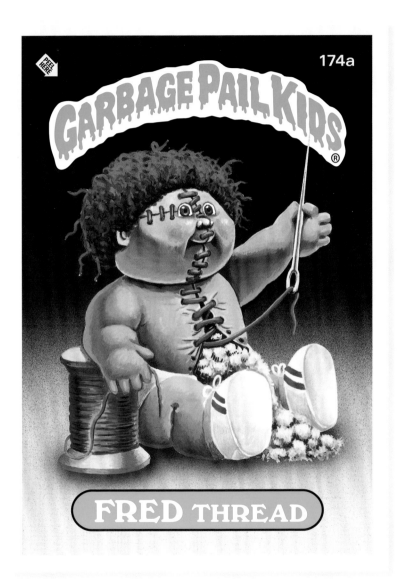

174a

GARBAGE PAIL KIDS

FRED THREAD

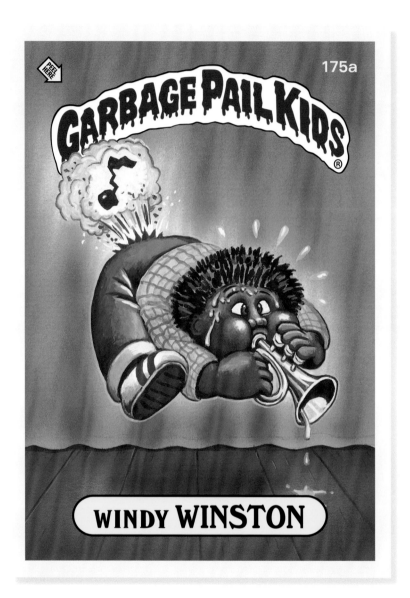

175a

GARBAGE PAIL KIDS

WINDY WINSTON

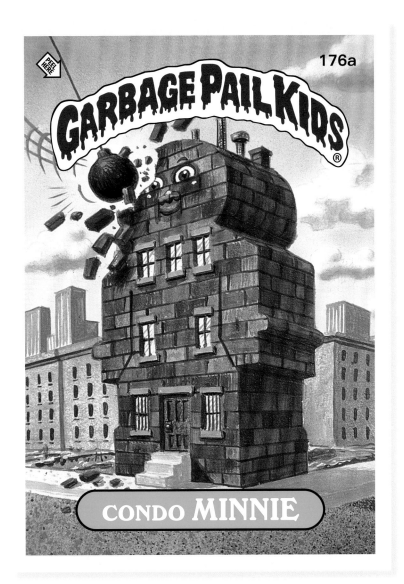

176a

GARBAGE PAIL KIDS

CONDO **MINNIE**

BILL DING 176b

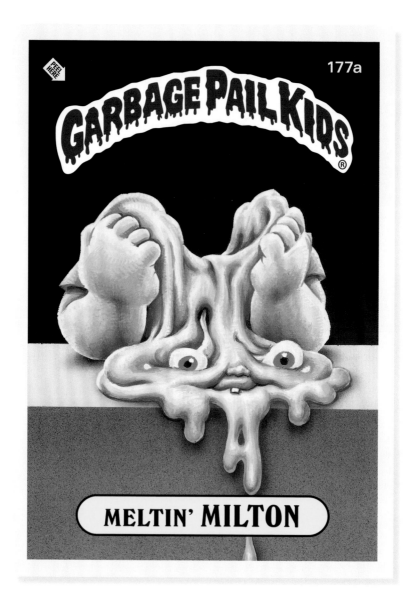

177a

# GARBAGE PAIL KIDS ®

PEEL HERE

## MELTIN' MILTON

LAZY **LOUIE** 177b

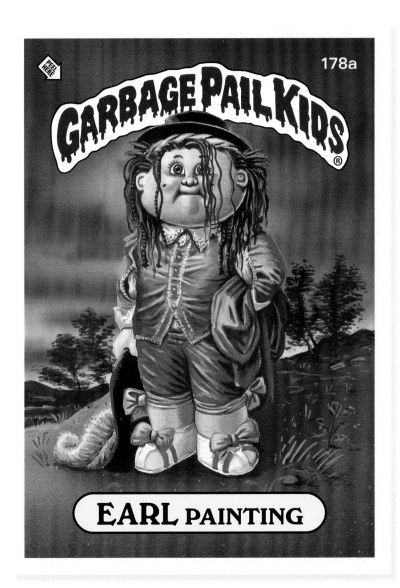

GARBAGE PAIL KIDS

**EARL** PAINTING

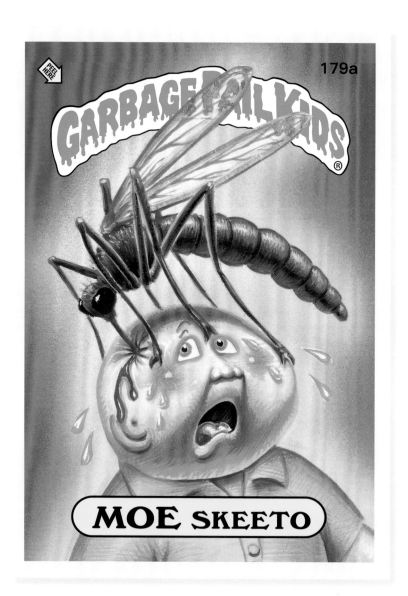

179a

GARBAGE PAIL KIDS ®

MOE SKEETO

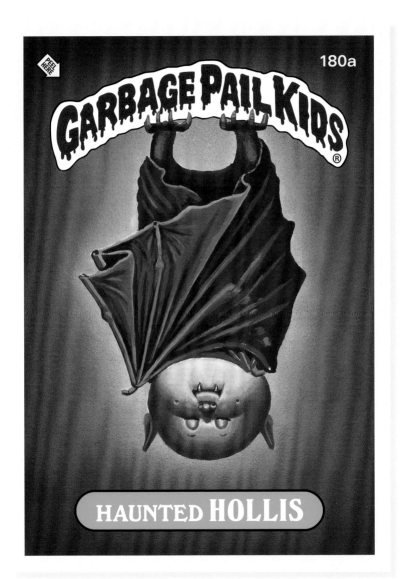

HAUNTED **HOLLIS**

BATTY **BARNEY** 180b

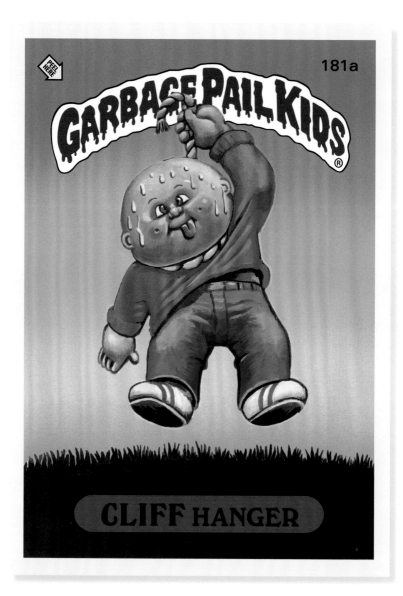

181a

GARBAGE PAIL KIDS ®

CLIFF HANGER

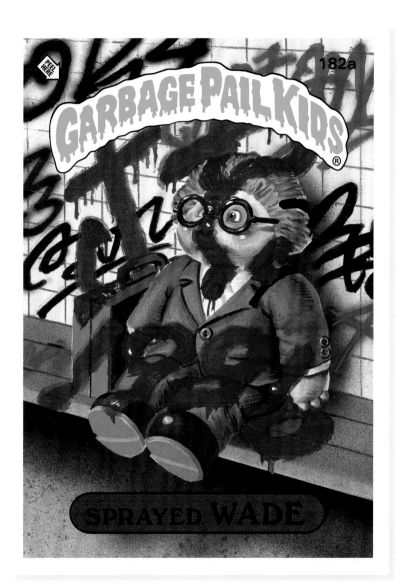

182a

GARBAGE PAIL KIDS

SPRAYED WADE

TAGGED TAD 182b

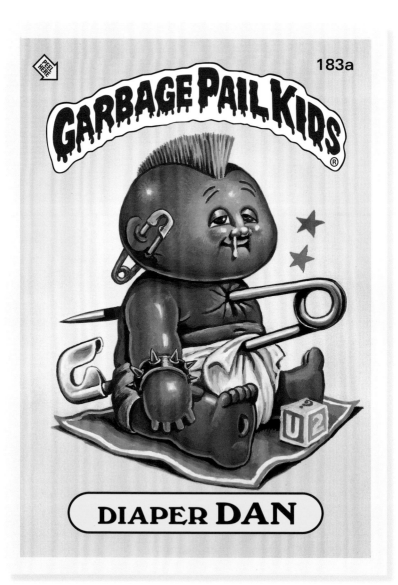

183a

GARBAGE PAIL KIDS®

DIAPER **DAN**

PINNED **PENNY** 183b

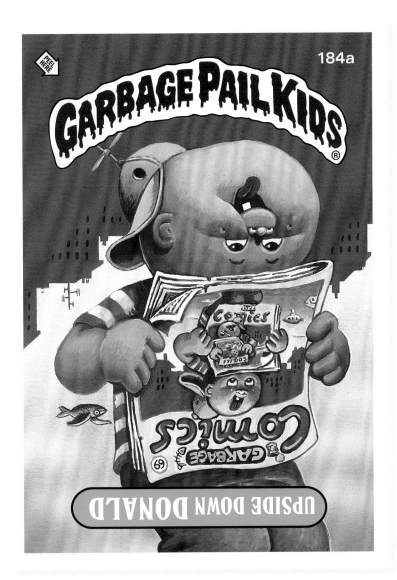

184a

GARBAGE PAIL KIDS®

UPSIDE DOWN DONALD

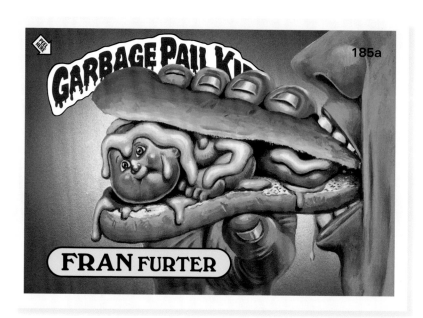

185a

FRAN FURTER

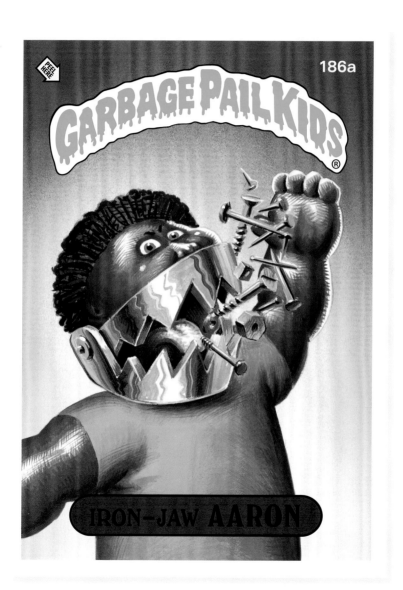

PEEL HERE

186a

GARBAGE PAIL KIDS

®

IRON-JAW **AARON**

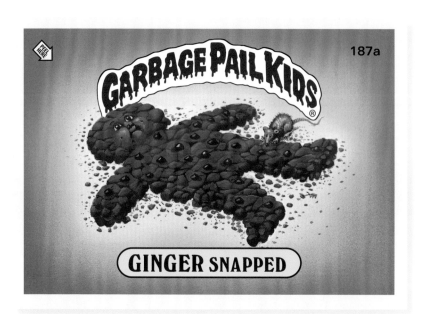

187a

**GARBAGE PAIL KIDS**

**GINGER SNAPPED**

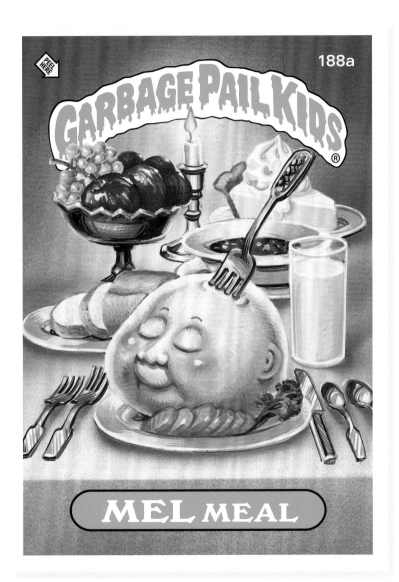

MEL MEAL

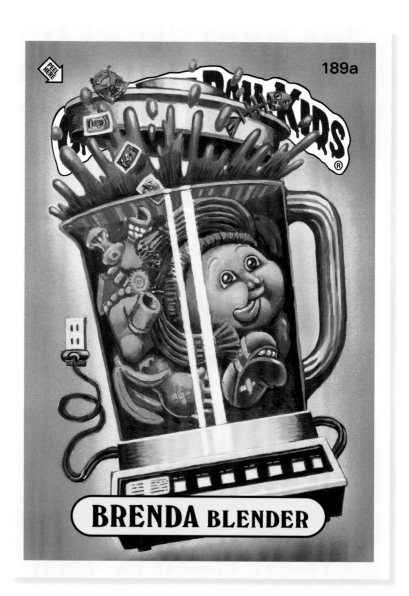

189a

**BRENDA** BLENDER

JUICY **LUCY** 189b

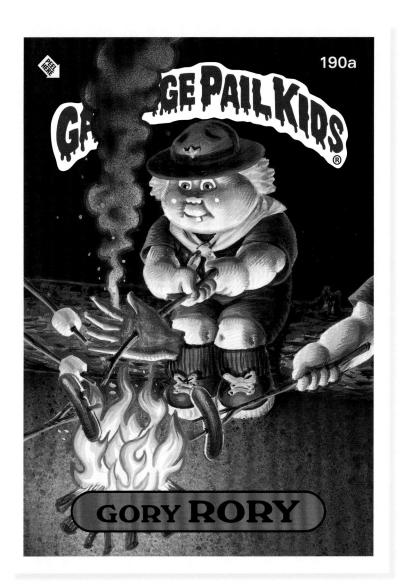

190a

GARBAGE PAIL KIDS

GORY **RORY**

GIL GRILL 190b

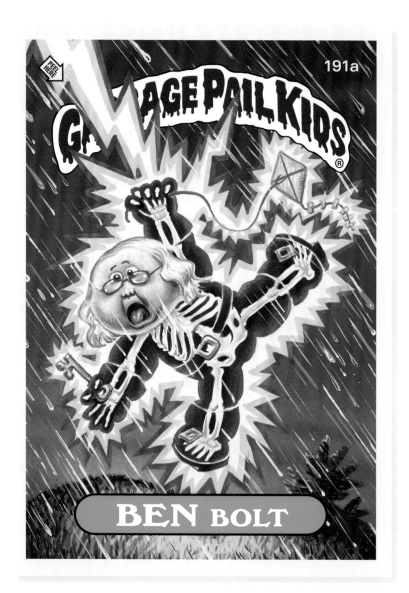

191a

GARBAGE PAIL KIDS ®

BEN BOLT

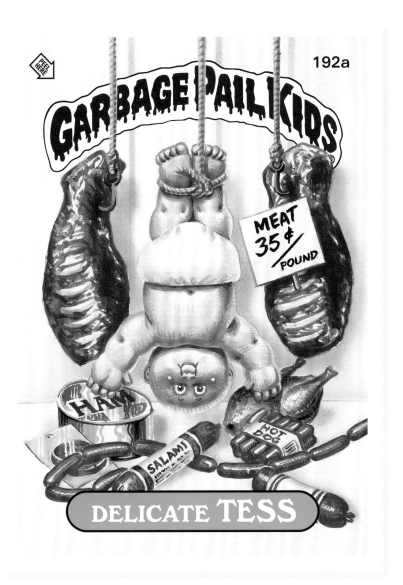

PEEL HERE

GARBAGE PAIL KIDS

MEAT
35¢
/POUND

HAM

SALAMI

HOT
DOG

DELICATE TESS

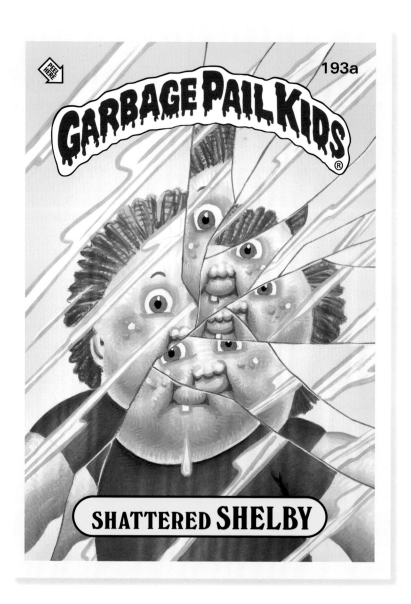

SHATTERED SHELBY

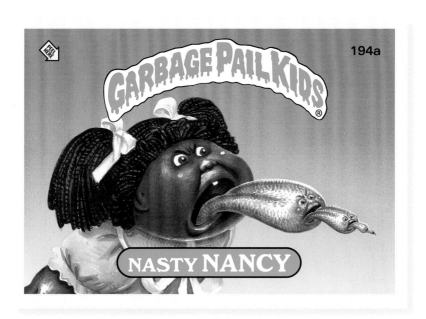

194a

GARBAGE PAIL KIDS ®

NASTY NANCY

RAZZIN' ROSLYN 194b

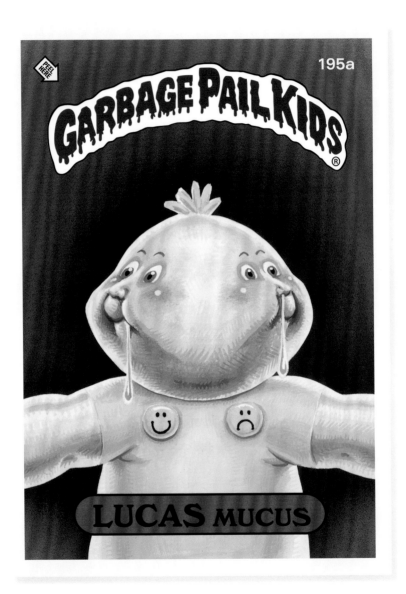

195a

# GARBAGE PAIL KIDS ®

LUCAS MUCUS

DOTTY DRIBBLE 195b

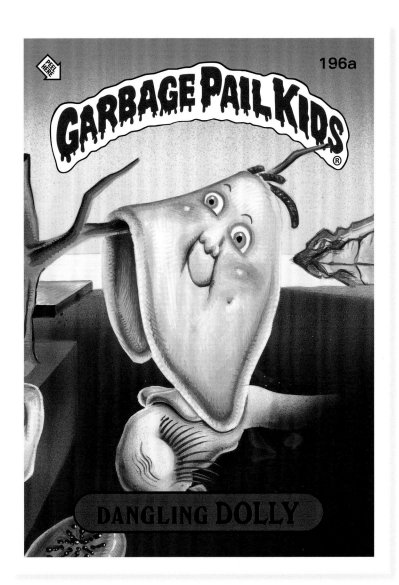

196a

GARBAGE PAIL KIDS ®

DANGLING DOLLY

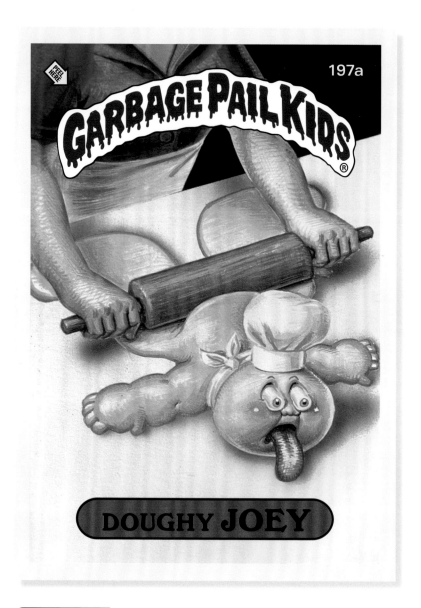

197a

**GARBAGE PAIL KIDS**®

**DOUGHY JOEY**

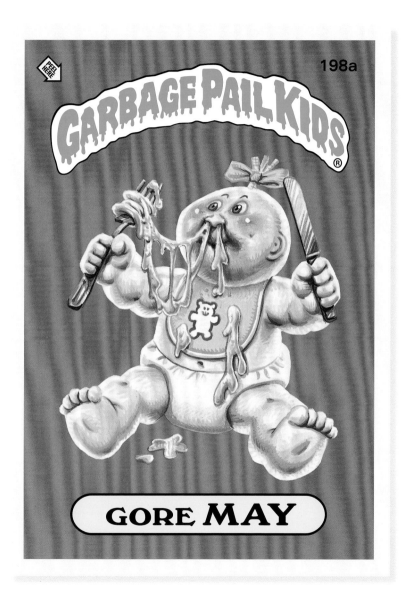

198a

# GARBAGE PAIL KIDS

®

## GORE MAY

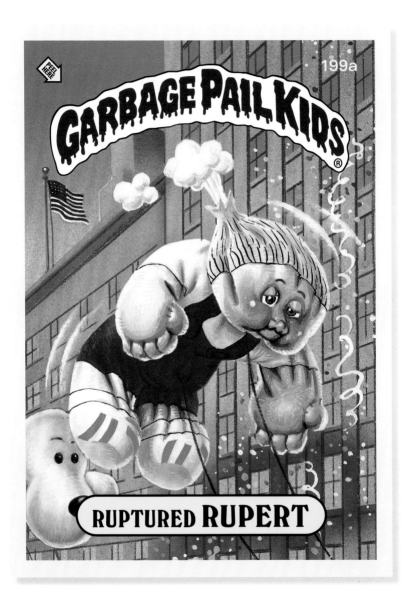

GARBAGE PAIL KIDS

199a

RUPTURED **RUPERT**

GASSY **GUS** 199b

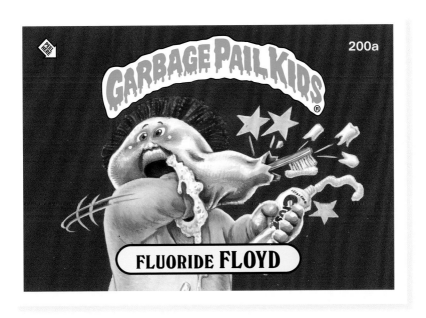

200a

FLUORIDE **FLOYD**

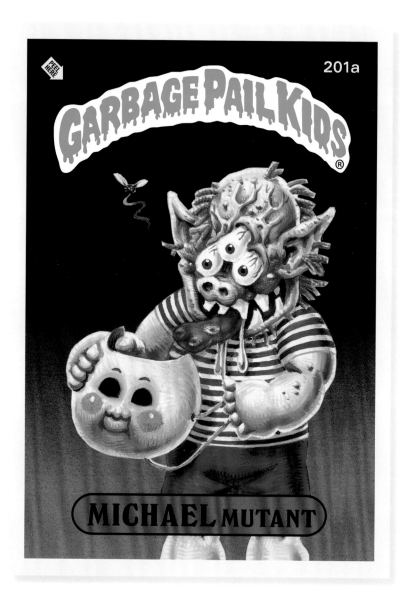

201a

GARBAGE PAIL KIDS

®

MICHAEL MUTANT

ZEKE FREAK 201b

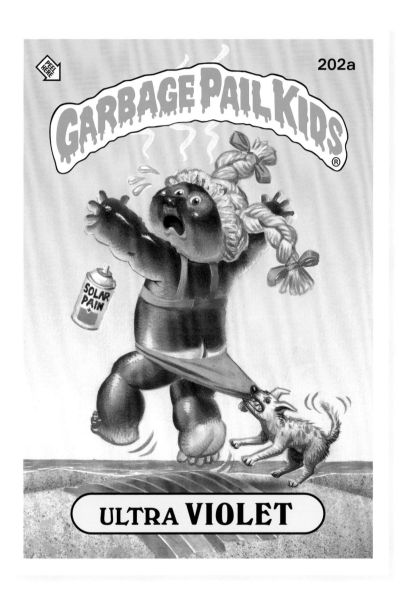

**202a**

GARBAGE PAIL KIDS

SOLAR PAIN

ULTRA **VIOLET**

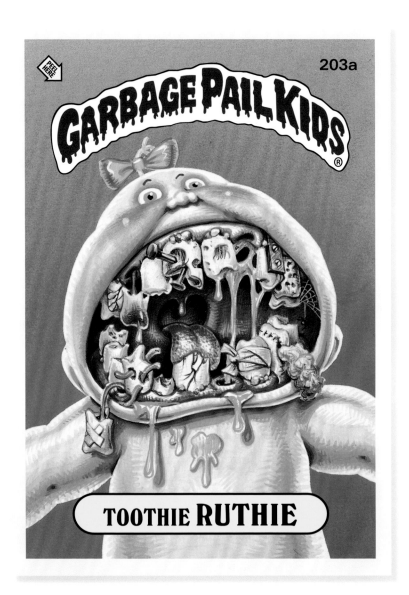

203a

GARBAGE PAIL KIDS ®

TOOTHIE **RUTHIE**

DENTAL **FLOSSIE** 203b

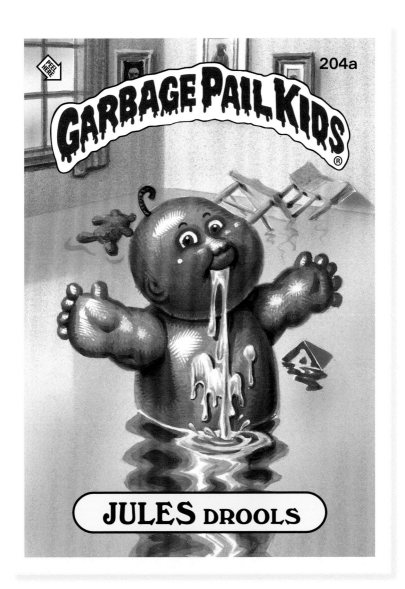

204a

GARBAGE PAIL KIDS ®

**JULES DROOLS**

KIT SPIT 204b

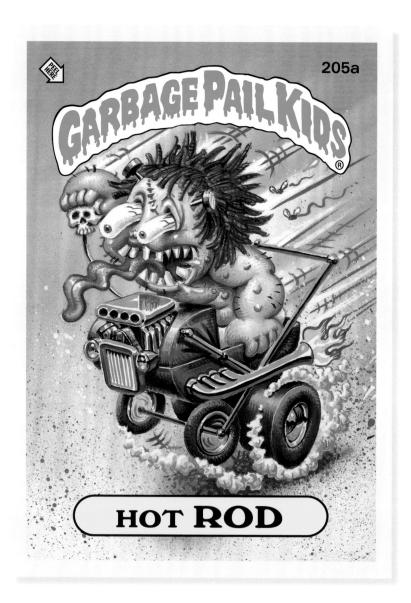

205a

GARBAGE PAIL KIDS

HOT **ROD**

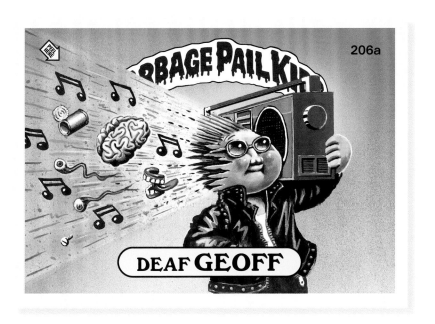

206a

DEAF GEOFF

# POPPING OUT GARBAGE PAIL KIDS

### by JOHN POUND

The early 1980s saw punk rock, personal computers, Rubik's Cubes, *Star Wars* sequels, video games, Reaganomics, and AIDS.

In California I was painting lurid underground comix covers, heavy metal–style art prints, and fantasy book covers.

Meanwhile, in New York, while creating comix, Art Spiegelman was also art directing Topps Wacky Packages stickers, which parodied products sold in stores. In 1984, Art called and asked if I could paint a few Wacky Packages. I loved humor art, so it sounded great. I did nine paintings from their gag roughs.

One idea, sketched by Mark Newgarden, was "Garbage Pail Kids," a parody of Cabbage Patch Kids dolls. But that image was never printed when Topps decided to do a whole series of Garbage Pail Kids stickers. They asked several artists to each draw some idea sketches plus a color rough to show how the cards might look. I got carried away, doing about fifty pages of loose sketches, with lists of ideas and names. I planned to redraw the six best ideas to look more professional, and send those in. But my wife, Karen, said, "Don't redraw. Send them everything. They already know you can paint." Wise words. Topps liked the ideas and sketches I sent in, and the color example, so they asked me to paint forty-four stickers for Garbage Pail Kids (only forty-one were used). Art said having all the paintings done by one artist would give the set unity.

The deadline was two months away. That meant doing one painting a day. For covers or art prints, one painting took two to five weeks, but there was no time for perfectionism. I had to get organized. I broke each painting into little one-hour tasks: sketch rough layout; trace tight pencil; send copies to Topps for approval or revisions;

color rough; paint flesh and hair; paint clothes; paint props; and airbrush the background.

Art assigned me ideas to paint from the ones I'd sent in, and from others that artists like Mark Newgarden had developed.

Using shock tactics for maximum impact, GPKs (as they came to be known) would be gross, mean, snotty, rude, and rebellious. But since I had to look at these violent, miserable, and disgusting kids all day while painting them, I selfishly wanted them to also feel good to look at—to be cute and lovable while spewing mayhem, disasters, and wild, crazy nonsense like they're proud to be weird!

Designing the stickers was simple: Put an upright figure in the middle. Have the logo above, the name below, and room around the edges to peel away the die-cut sticker. Instead of all-white (or all-black) backgrounds, introduce colored airbrushed backgrounds, each one different, for variety, mood, and space. Make the figures compact and sculptural, like they could be actual dolls.

After all the paintings were done, Topps held a GPK naming session, inventing two names per painting, for both the "a" and "b" stickers.

Len Brown was very active at Topps as their creative director, overseeing everything in a good-natured, friendly way. I had several phone calls with him over ideas and revisions for GPKs.

Topps had great distribution. Once Series 1 was released in 1985, GPK sales went through the roof and we started work on Series 2.

Again I painted all the front artwork (forty-two cards this time). Series 2 introduced some horizontal designs (Matt Ratt, no. 66) and closeups (Gorgeous George, no. 73). In Series 3 a "Mr. Hand" appeared, victimizing kids (Punchy Perry, no. 97). More-defined backgrounds started

appearing (Marvin Gardens, no. 92). Tom Bunk, who drew card backs for Series 1 and 2, started painting some fronts (Hurt Curt, no. 89).

The paintings were unsigned, and Topps never shared hate mail, or fan mail, with the artists.

Reactions to GPKs varied. Kids loved them. Some parents hated them. Schools banned the stickers because kids traded them in class. A couple of reviewers wrote about how these gross stickers were done with love.

Licensed posters, binders, and toys were made. A cheesy movie was released in 1987. Crude imitations appeared on the market.

In 1986 the makers of Cabbage Patch Kids sued Topps over Garbage Pail Kids. Topps settled out of court, and we were able to continue making new stickers.

Growing busier, Art delegated some GPK art directing and phone calls to Mark Newgarden. Like Art, Mark was great to work with. Our phone sessions over gag ideas, pencils, and adding more twists frequently broke out in laughter. We realized college doesn't prepare you for real-world decisions like whether barf should be smooth or chunky.

To help refresh the idea pool, I continued submitting GPK sketches to Topps, drawing several on a page, like incoherent comic strips.

By Series 6 in 1986, James Warhola had also started painting fronts. The art gradually grew more detailed and finished, taking longer to complete. Tom Bunk's paintings were sometimes generously filled with background gags.

With Series 10 in 1987, Topps changed the design of GPKs: the arched logo became straight; the eyes, ears, and number of fingers changed; and GPKs had to have hard plastic bodies, cracked somewhere. They went from cute to ugly.

Series 16 was completed in late 1988 but not published. The wild GPK party began to wind down.

In the 1990s, Topps tried publishing other humor sticker sets, like Trashcan Trolls and

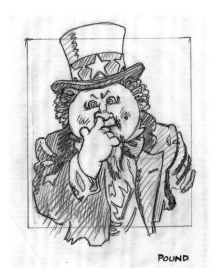

"Snooty Sam"/ "U.S. Arnie," Garbage Pail Kids no. 110 (Series 3, 1986). Pencil art by John Pound

Bathroom Buddies. I began developing my own cartoon paintings, drawings, and stories for book projects, and making digital art.

In 2002, Topps began selling GPK original art on eBay for prices we never would have imagined.

Then, in 2003, GPKs returned as eighties pop culture resurfaced. Under art directors John Williams and Jeff Zapata, Topps began making All-New Series (ANS) Garbage Pail Kids. ANS set 1 featured unpublished Series 16 paintings, plus new art by Tom Bunk and myself, with gags by Jay Lynch. Oddly, sticker numbers did not continue from where they left off, at 620, back in 1988, but started over at 1. Topps released seven ANS sets, adding more artists to the team, and GPK Flashback sets reprinting 1980s GPKs.

Overall, making Garbage Pail Kids was a dream job. I'm deeply grateful to have worked with a team of many talented creators, sharing crazy fun with the world.

**JOHN POUND** has painted art prints, book covers, comics covers, and hundreds of Garbage Pail Kids stickers. He also writes code that draws instant random art books.

# INDEX

Numbers refer to book pages

**Topps®**

# GARBAGE PAIL KIDS™
## STICKERS BUBBLE GUM